B 3103

The Technique of

NEEDLEPOINT LACE

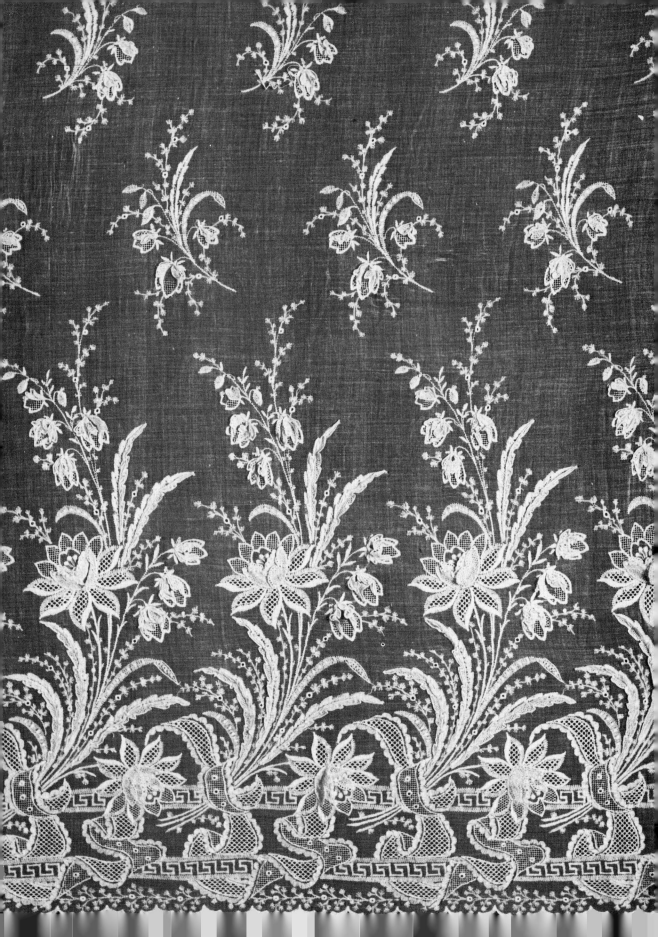

The Technique of
NEEDLEPOINT
LACE

Nenia Lovesey

B T Batsford Limited London

Dedicated to Dorothy Humphry and Dorothy McComb

Frontispiece A muslin flounce, showing attached needlepoint petals and leaves, the property of The Royal School of Needlework

© Nenia Lovesey 1980
First published 1980

ISBN 0 7134 1098 1

Filmset by
Willmer Brothers Limited, Birkenhead

Printed in Great Britain by
Fakenham Press Ltd.
Fakenham, Norfolk

for the publishers
B T Batsford Limited
4 Fitzhardinge Street
London W1H 0AH

CONTENTS

Acknowledgment *6*

Introduction *7*

Four centuries of lacemaking *7*
Alençon Point *17*
Glossary *18*

History and characteristics *19*

Venetian Point lace *21*
Spanish lace *25*
French lace *29*
Brussels lace *38*
English lace *41*
 Coggeshall lace *43*
Traditional Irish laces *45*
 Carrickmacross lace *45*
 Limerick lace *45*
German laces *49*
Danish lace *52*
 Hedebosyning lace *52*

Designing *53*

Preparation *65*

The pillow *67*
Base fabric *67*
Needles *67*
Threads *67*
Fill de Trace *69*
Laying the cordonnet *70*

Working methods *71*

General hints *73*
Petit Point de Venise *73*
Venetian Point variation *74*
Point de Venise *74*
Belle Point de Venise *76*
Venetian doodle *76*
Spanish Point *79*
Point de Sorrento *80*
Spanish lace *80*
 Tenerife lace wheel *80*
Alençon mesh *83*
 Whipped stitch *83*

Réseau for Argentan Point *83*
 Bride d'Epingle *83*
Ardenza Point *84*
Ardenza Point bar *87*
Lattice filling *89*
Brussels lace *89*
 Point de Bruxelles *89*
 Double Brussels stitch *91*
 Treble Brussels stitch *91*
 Inverted pyramid *93*
Corded filling *93*
Pea filling *95*
 Pea stitch variation *95*
Filling an oval space *95*
Point de Grecque bar *96*
Venetian picots *97*
Loop picot *97*
Bullion bars *101*
Purls *101*
Russian bars *102*
Alençon beads *102*
Hollie point or holy stitch *103*
Wheel ground No 1 *103*
Point d'Angleterre wheel filling No 2 *105*
Filet stitch *106*
Netting *109*
To work the Fisherman's knot *110*
Working details for a hammock *111*
Carrickmacross lace *111*
Limerick lace *115*
 Limerick lace fillings *122*
Filling stitches for Filet or Limerick *124*
Point Croisé *125*
Point Tiellage *125*
Point d'Esprit *126*
Woven bars *126*
Woven pyramids *126*
Wheel Garland *130*
Russian filling *130*
Buttonhole rings *131*
Armenian lace *134*
 Smyrna or Rodi stitch *134*

Suppliers *137*
Bibliography *139*
Index *141*

ACKNOWLEDGMENT

I would like to thank the following: The Royal School of Needlework for allowing the pieces of lace to be photographed and Miss Bartlet in particular for encouraging me to write the book.

Dianne Hebbs and Mary Harbard for the endless typing and retyping while collating the text, and Maureen Walker for typing the complete work. Albert Salmon for reading and correcting the text. Roger Cuthbert for his patience and understanding while taking the photographs, plus many more whom there was no room to include. Doreen Holmes and Irene Lewis for working through the Irish laces and my many students who have worked the stitches from the directions and diagrams given in the chapter on working methods.

Last, but by no means least, I thank my husband for accepting all the inconvenience caused with such good humour and fortitude.

NL *Wokingham 1980*

INTRODUCTION

There are two distinct types of handmade lace. One, made entirely with a sewing needle and consisting chiefly of elaborate buttonhole stitches, is called Point lace. The other is known as Bobbin or Pillow lace which is a form of plaiting and twisting, worked with bobbins on a firm base in the shape of a pillow. It is not difficult to distinguish between the two types, although some of the work is so fine that without the aid of a magnifying glass it would be hard to define the stitches. Pillow lace will be plaited and woven. In some instances the design is worked in a woven linen stitch and then joined together with plaited bars; sometimes it is worked in one piece but the threads always lie over and under each other as in weaving.

In needlepoint the design is outlined with a continuous thread called a cordonnet, closely oversewn or tightly buttonholed for the whole of its length, and the patterns are formed by threads looped together with a great variety of stitches. There is a lace that combines both techniques called Tape lace. The design is laid in with a braid of Bobbin lace and this is then joined together with fillings and bars made with needlepoint stitches. In this book the emphasis is on Point lace, made with a needle and thread.

Information on the subject is scarce, so the aim is to bring together a little of the history and the methods of construction of as many Point laces as possible. As the same types of lace have been made in many different places, identification is very difficult. Each period seems to have had its own distinguishing feature, but one cannot be dogmatic about the origin of any one piece of lace. Brussels and Alençon copied the style of Venice and, in turn, Italy made a net ground copied from the nets made in Flanders, while refugees from one persecution or another brought their knowledge of lace to their adopted countries to complicate the origins even further. However, as each lace originated in a particular country or even a certain town, then it will be by this name that it will be identified in this book.

Four centuries of lacemaking

The oldest form of lace is netting, made either with the aid of a netting shuttle or with a needle, along with another technique called Sprang which is made by manipulating the threads of a stretched warp. Archaeologists have dated a hairnet found in the Satrupholm Bog near Schleswig, Germany, at 3000–4000 B.C. Another net made from single-ply wool was found in the Haraldskar Bog at Vejle, Denmark; this one is dated at 500–800 B.C. Both these nets were made by the Sprang technique. Many pieces of this type of lace have been found dating back many years B.C. in places as far apart as Denmark and Peru.

Netting is considered to be the technique used for the laces mentioned in the Bible, but the needlepoint lace covered in this book is of a much later period. True needlepoint lace started life under the title of Punto Tirato. Although it looked very much like the Russian Drawn work of today, it was made differently. It was worked on very loosely woven linen material; the threads were not cut or pulled out as in cut work or rococo, neither were any surface stitches added. The threads were drawn apart by closely oversewing with a silk or linen thread, which gave the appearance of net formed by small squares. The unworked part of the linen formed the design. This grounding gave an angular appearance to the work which was overcome by means of a cordonnette of silk or linen being laid over the outline of the

Opus Tiratum–Punto Tirato. This is a modern piece but it does show the type of work done in the twelfth century. It was used for altar cloths and winding sheets. Early examples show groups of horizontal and vertical drawn threads, overcast to form a square network. Towards the seventeenth century, figures and heraldic devices were used, being formed by the background material, while the background was worked with coloured threads (page 8)

Bands of pulled thread forming a square network. The corners of cutwork are filled with wheels and buttonholed loops. Detail of a handkerchief belonging to Elsa Took (page 9)

7

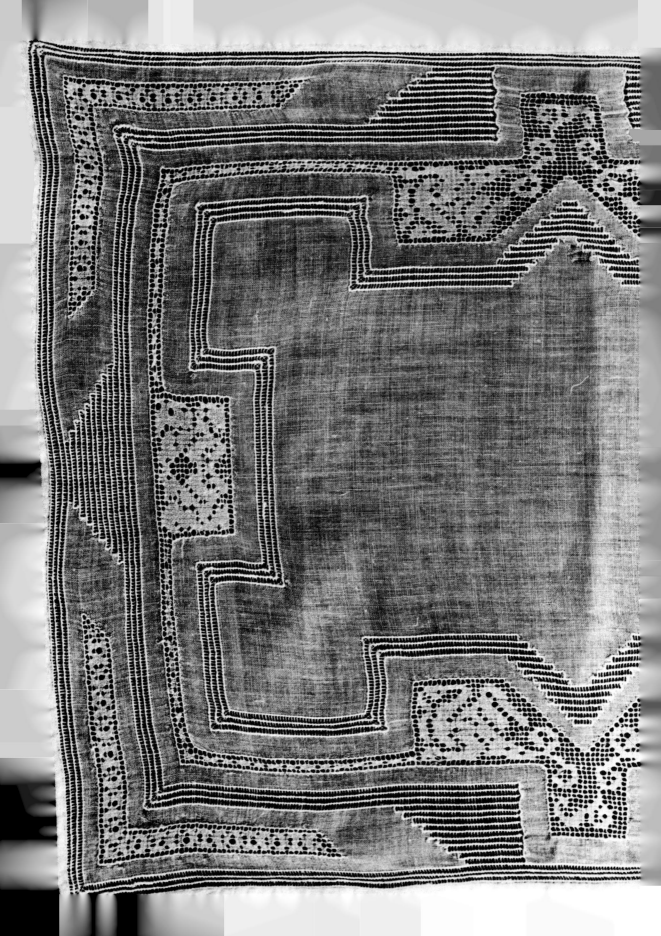

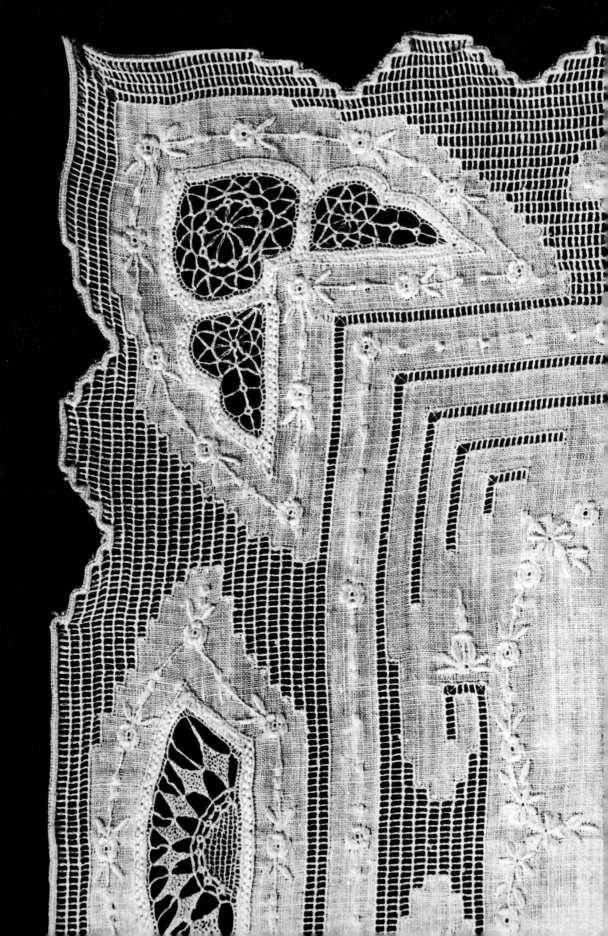

design and oversewn to the material. The designs were often of the mythical nature of beasts or horses and the work was done in bands of 75 to 100 mm (3 to 4 in.) in depth. This type of work was of Italian origin. Later the work was done in Spain, the designs then being much more of an oriental character, with Moorish arabesques and scroll work. It was also found in Greece with classical square designs.

From this developed Punto Tagliato. Here squares or shapes were cut from the material and the spaces filled with a'jours. Woven bars with picots appear in this type of lace embroidery along with the close stitch rope forming the cordonnette. This was still embroidery, for the threads still relied on the background material for anchorage. Cut work was followed by Reticella which continued to become more ornate with more and more of the linen being cut away and the larger spaces being filled with more elaborate stitches. Like many of the arts, such as sculpture and painting, embroidery and lace were nurtured in the convents, therefore most of the early forms of lace were made for the Church and for ecclesiastical vestments and apparel. The exquisite work could only have been done with the time and patience found in the convents and monasteries; usually the work was a labour of love for a favourite saint.

In the sixteenth century the art of embroidery formed a principal occupation of the Italian and Venetian ladies of the Court and some of the samplers or 'sam cloths' are still to be seen at the Victoria and Albert Museum, London, dated around 1650. They show the character of the needlepoint practised then. Many of the old pattern books published in Venice at that time have been reproduced by means of the photo-lithographic process but are not on general display in any of the museums for obvious reasons.

In the seventeenth century a new type of lace was conceived; this was called Punto in Aria which means 'stitches in the air'. This now meant that the worker was no longer dependent on the material background and the angular

designs became a thing of the past. A pattern, called a Passement au Fuseaux, with the design stamped onto it, was attached to another strong piece of linen. A cordonnet was couched down to both materials to form the basis for the design. The fillings were worked into the design spaces; these were joined together with bars or mesh. When all of the design and background were finished the cordonnet was buttonholed or oversewn to give a slightly raised outline. After this, the stitches holding the cordonnet were cut between the passement and the background material. The work was then lifted off to reveal the delicate lace that had been formed. A whole new range of stitches or fillings was invented along with special grounds. These groundings were given names such as Point de Venise, Point Neige, Venetian Point, Rose Point, Point Plat, Plat de Venise and Coralline. The most beautiful of all was the Gros Point de Venise or the raised Venetian Point. Parts of the cordonnette were padded with double or treble threads and the outlines of the different parts of each individual motif received the same treatment. Each padded area was then oversewn or buttonholed and the edges were decorated with tiny loops. In some places even the tiny loops received four to six minute picots. All this detail was added to the infinite varieties of fillings used to build up the design to make an extremely beautiful fabric.

Certain stitches were used for each different type of lace, but as time went by the stitches became common to all lacemaking countries. It is the background meshes which usually denote the origin of the lace. Each country had designs and periods that set the individual lace apart for a time, but the fillings remained much the same from Italy, north through the continent of

Detail of a tablecloth showing woven bars with picots, worked by the author

Italian cutwork bands
Punto a Reticella or Punto in Aria. Reticella is mentioned in the Sforsa Inventory in 1493, but was at its best in the sixteenth century. The first pattern book for this kind of work was by Federico Vinciolo and appeared in Paris in 1587. The book contained patterns that had been worked in Italy for fifty years previous to this date. This work is still produced in the Greek Islands and is often referred to as Greek lace (page 12)

A silk stole belonging to The Royal School of Needlework worked in cream filo floss using needlepoint stitches with surface embroidery (page 13)

Europe to England and the Scandinavian countries.

Mention has been made of both a cordonnet and a cordonnette. The former is the foundation thread which is couched round the design for the lace to be worked on. The cordonnette is the thread or threads that make the raised outline, as found in raised Venetian Point.

It is useful at this point to include some of the technical terms that apply to needlemade lace. As well as being interesting from the historical point of view, the terms also give a very clear idea of how the lace progressed from start to finish.

If the solid parts of the design were worked level and without an outline, it was known as Flatwork or Flat Point. When the edges were padded it became Raised Work or Gros Point. Whichever way it was worked, the design was called the Pattern.

The connections within the Pattern were known by various names. In England they were the Ties, in France they were called Brides. Italy and parts of Spain referred to them as Legs. Sometimes these connecting bars were overcast, forming a rope-like appearance, at other times the bars were covered with close buttonhole stitches. When worked with buttonhole stitches, the method was called Brides Claires. When additional Picots were worked into the buttonhole stitches, the bars became known as Brides Ornées.

The connection of the Pattern in this fashion is found in the earlier laces. It was a time-consuming method and was very costly to produce. Later, the Pattern was held together by Meshwork or Réseau, which is rows of openwork buttonhole stitches. The two different types of grounding were called Point Guipure à Bride or Guipure par Excellence; this was the early work or any lace connected with bars. The lace worked by the mesh method was known as Point Guipure à Réseau or Grounded Point.

The flat part of the Pattern was called the Toile; this was always worked in close buttonhole stitch forming a 'clothwork'. Centres of the designs within the Pattern were filled with variations of the buttonhole stitch, woven wheels and other fancy stitches. These were called the Fillings, Jours or Modes.

Round the outside of the cordonnette little loops with picots were formed, called Picots, Thorns or Pearls. At other times parts of the cordonnette were worked separately in the form of rings which had picots worked on top of loops, which in turn were applied to the lace. These added adornments were the Couronnes.

The footing, which was the edge of the lace to be sewn to the material, had a very narrow strip of lace sewn to it. It was a braid of bobbin lace called the Engrêlure. If this braid was accidentally snipped while the lace was being removed from one garment to another, it was easily replaced or repaired. It saved the costly needlemade lace from being damaged.

A band of bobbin lace called the Engrêlure, sewn along the top of the needlepoint lace for attaching to a garment

Point de Gaze fan, the property of Kathleen Barley. The lace picks up the design on the spines (page 16)

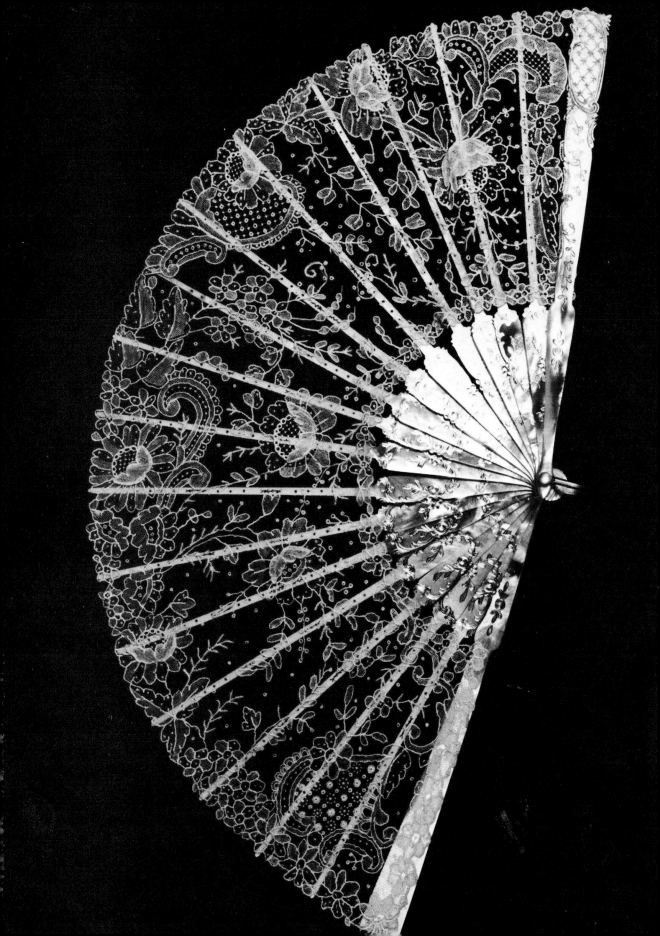

Alençon point

Alençon point was made by a number of different lacemakers, each trained to work a special process of the lace. Each had a title; this denoted which part of the lace was her speciality. By reading through the list of workers, it can be seen how the lace was worked.

The Piqueuse – pricked the holes in the parchment and linen on which the lace was to be made.

The Traceuse – outlined the pattern with two threads, couched at regular intervals with minute stitches. This is the holding thread that the lace stitches would be worked on, called the cordonnet.

The Réseleuse and the Fondeuse – worked the mesh or réseau grounding.

The Remplisseuse – worked the Toile of the Pattern in close buttonhole stitches.

The Brodeuse – worked the surrounding cordonnette.

The Modeuse – was a more advanced needlewoman who worked the ornamental fillings or a'jours.

The Ebouleuse – collected together the separate parts of the design and cut the finished lace from the parchment pattern.

The Regaleuse – assembled each section and tacked it to green paper, which in turn was mounted on two layers of material.

The Assembleuse – delicately joined all sections together by an invisible seam known as Point de Raccroc.

The Brideuse, the Boucleuse and the Gazeuse – each had to detect faults and correct any mistakes.

The Mignonneuse – sewed on the narrow band of engrêlure.

The Picoteuse – then added the loops and picots to the cordonnette and raised fillings.

The Affiqueuse – checked for any inequalities and polished the surface of the design with an instrument called an afficot.

By following through each process given here, the present-day lacemaker will find the order in which to work her lace. In turn she will do the work of sixteen differently trained people and can be forgiven if her work is not up to the standard of eighteenth-century Alençon Point.

An embroiderer would find all the needlelace stitches an extension to her embroidery. Each stitch can be made independent of any background material; they can be used to give textures, another dimension, shading, or on their own.

Glossary

Afficot An instrument used for polishing the raised parts of the lace. Early afficots were made from highly polished wood, bone or ivory, in the shape of a miniature golf club. On the Continent and later in this country a lobster claw was cleaned and polished and set into a wooden handle: this was common practice amongst the poorer lacemakers.

A'jours Fillings for the insides of flowers and ornamental motifs within the design.

Appliqué A motif made separately and sewn onto a net ground.

Bars, Brides The connecting threads across spaces joining one motif or design to another.

Brides Claires Ornamented bars.

Buttonhole stitch Often referred to in the old history and pattern books as close stitch, Point None and Punto à Feston.

Beading Small loops formed along the edges of a woven bar.

Casket A space in the background entirely surrounded by the design.

Cordonnet The foundation threads that hold the working stitches.

Cordonnette A thick thread or threads laid round the main outline of the design and worked over in close buttonhole stitch; in some laces thick thread is overcast separately and attached to the outline after the lace is finished.

Couronne The decoration of the cordonnette, used mainly in Venetian Point and giving the finished lace the look of carved ivory.

Chansons à Toile Lace tells or songs sung while working the lace.

Coxcombs Another name for bars and brides.

Cartisane A gold or silver thread used as a cordonnette to outline a design.

Dentelle In France this denotes any lace having a scalloped edge.

Ell In 1101 a law was passed in England stating that an ell should measure 45 in. (114 cm) while a Flemish ell was only 27 in. (68 cm).

Overseers would mark the lace at the beginning, and every ell would then be marked, usually with a little round metal tag. The workers were paid by the ell.

Entoilage A plain mesh ground.

Fillings Fancy stitches used to fill enclosed spaces in the designs.

Fond, Champ, Treille, Entoilage, Fond de Neige The names given to ground work that supports the pattern or motifs. Found in old Mechlin lace groundings.

Finger A measure of length used by lacemakers, equal to 11 cm ($4\frac{1}{2}$ in.).

Half wheels Ornamental bars used when lace is thick and heavy.

Jours The same as fillings.

Lace Tokens These were regarded as legal currency up to the end of the last century. However, some tokens had the name of the overseer stamped on one side and were only accepted in one shop; that owned by the overseer.

Lud works, Lead works A term indicating fillings.

Opus Ancient name for needlework including needlemade lace.

Orphrey The broad band that adorns an alb which is part of a priest's vestment; it also bordered the robes of knights. A great deal of Venetian Point was used in this way.

Passement au Fuseaux The printed pattern used to work needlepoint lace.

Picot A small loop used to enrich an outline of a motif and also to decorate bars, etc.

Point de Raccroc A stitch used to join together réseau grounds. In the convents and lace schools one piece of lace could be made by a number of people. The best lacemaker was usually the Raccroc who joined all the work into one piece.

Point Plat A lace made without a cordonnette so there were no raised parts.

Punto a Feston Buttonhole stitch.

Toile A mesh or ground.

Toilé The pattern or motif the lace is composed of as distinct from the ground.

HISTORY AND CHARACTERISTICS

Venetian Point

It has been claimed that Venice originated the Punto in Aria which we now call Point Lace. An infinite variety of designs was produced there and it was also the centre for the best workmanship of that time. There are instances of records proving that a form of needle lace was made in Venice at the beginning of the sixteenth century. The pattern books of that period are all of the Reticella type of embroidery and are not the real Point lace. It was in the first half of the seventeenth century that Venice became the home of lace *par excellence*.

Two subdivisions of Venetian Point have been defined by Caveliers Merli in a booklet published early in the seventeenth century. These were Punto Tagliato a Fogliami, which we now call Raised Point, and Punto in Aria, the flat point. There are definite distinguishing characters of Venetian-made Point Lace.

In the early Venetian Point, flat or raised, the patterns are always connected by an irregular network of pearled brides and the number of picots attached to one single branch of the brided network never exceeds two.

The design of the Punto Tagliato a Fogliami represents a scrollwork of flowers, stalks and leaves with raised outlines and centres, purled all round in single rows. In some of the laces the flowers stand in double and treble relief. A variety of fillings is used for the flower motifs while the stalks and leaves are always worked in solid stitches. This lace was used in great quantities by the high dignitaries of the Roman Catholic Church for chasubles, stoles, maniples, corporal cloths and palls. The laity had to be satisfied with collarettes, berthes and laced bands.

Various other names have been given to Venetian Point apart from those mentioned above; Gros Point de Venise, Cardinal's Lace, Pope Point and Point Plat de Venise, while Point d'Espagne and Guipure are two other laces made in or near Venice. There is confusion over the origin of Point d'Espagne but, although it may have been made occasionally in Spain under Italian influence, it was certainly of Venetian origin. Guipure now denotes lace made from braid or tape with needlepoint fillings and bars; in no way can it rate the same as

the fine needlepoints. Raised Point or Gros Point de Venise can be distinguished by the boldness and continuity of the designs; secondly, the cordonnette is a prominent feature. Additional threads are laid to thicken special areas of the design, then closely buttonholed. The buttonhole stitches are often edged with a row of loops decorated with picots. The design is held together with brides or bars but these do not form an essential part of the design itself as in some laces. Raised point has been described as 'scolpito in relievo' (sculptures in relief). All through the Renaissance period, when this lace was at its peak, it was a very apt description.

Distinctions between Gros Point de Venise and Rose Point are few; the style is modified, not changed. With Rose Point the cordonnette for each motif is laid and worked in buttonhole stitch variations. Scrolls, leaves and flowers as well as mythical figures are used. These form the design and all are joined together with bars. The loops of the buttonhole stitches that outline these motifs are then worked again with loops and picots. Tiny stars or roses are worked into suitable parts of the design.

Sometimes the roses or stars are worked in three layers, poised one on top of the other, the whole surface of the lace being sprinkled with tiny motifs, somewhat resembling a snowfall. It is then classed as Point de Neige. Another feature that marks this lace from Rose Point are the fine brides or bars that connect the design; these are purled and dotted with loops and stars as well. Most of this lace requires a magnifying glass to discern the intricacy of the stitches.

The finest lace of these varieties was worked in the late sixteenth and early seventeenth centuries; the designs were bold and of the Renaissance character.

Flat Venetian Point followed and, as the name implies, raised work was altogether absent. This is the Venetian Point à Réseau which was

Sixteenth-century Venetian Point. The scrolls, mentioned in the chapter on designing, are obvious in this collar. The diamonds in the close buttonhole toile are made by missing stitches in one direction and working them back into the loops in the next row. The ravages of time make the cordonnette clearly visible underneath the raised work, while the ends of the drawstrings can be seen to have beautifully sculptured flowers attached (pages 22, 23)

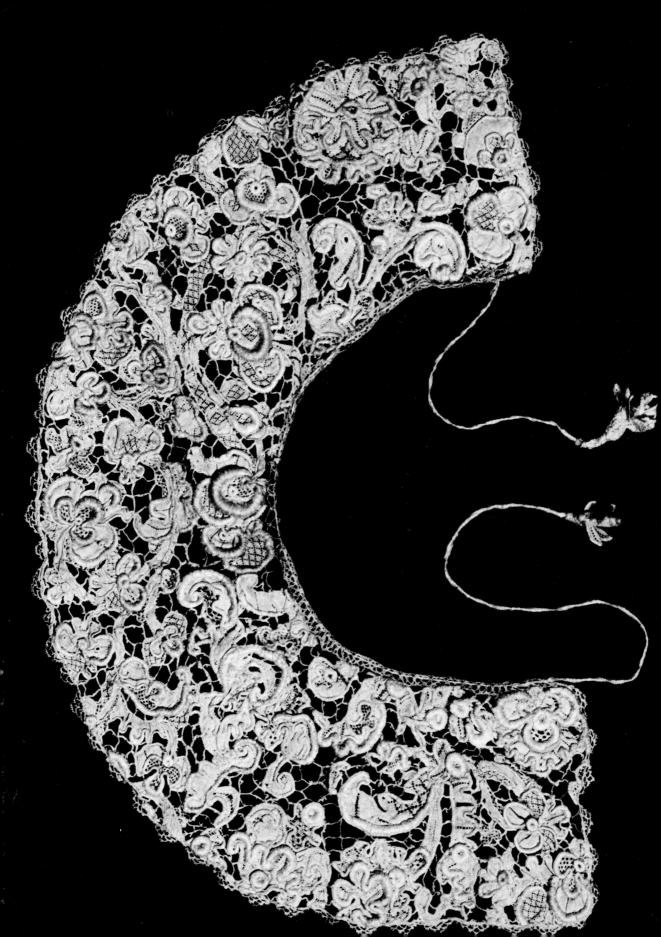

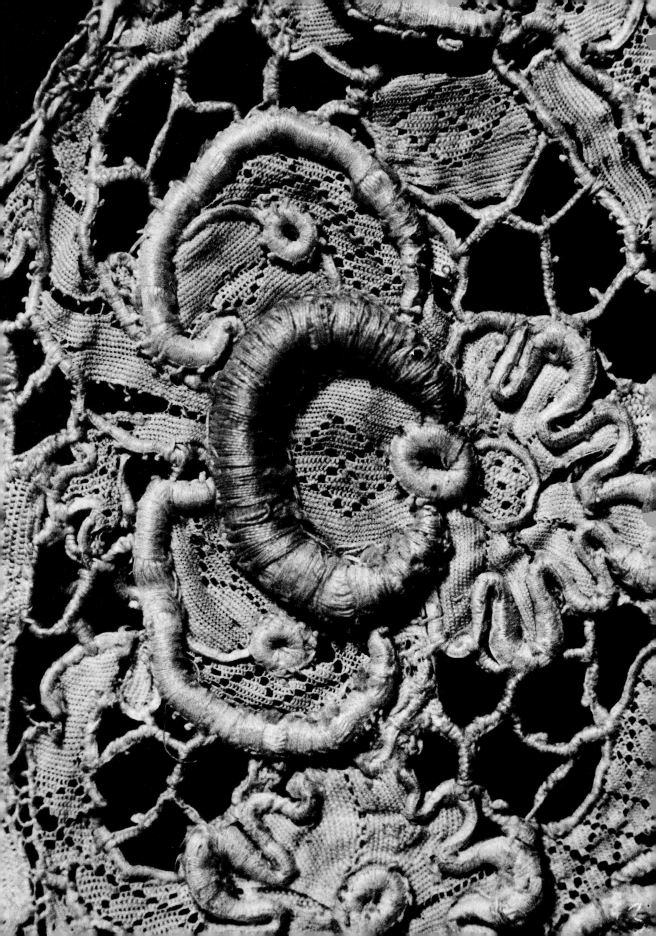

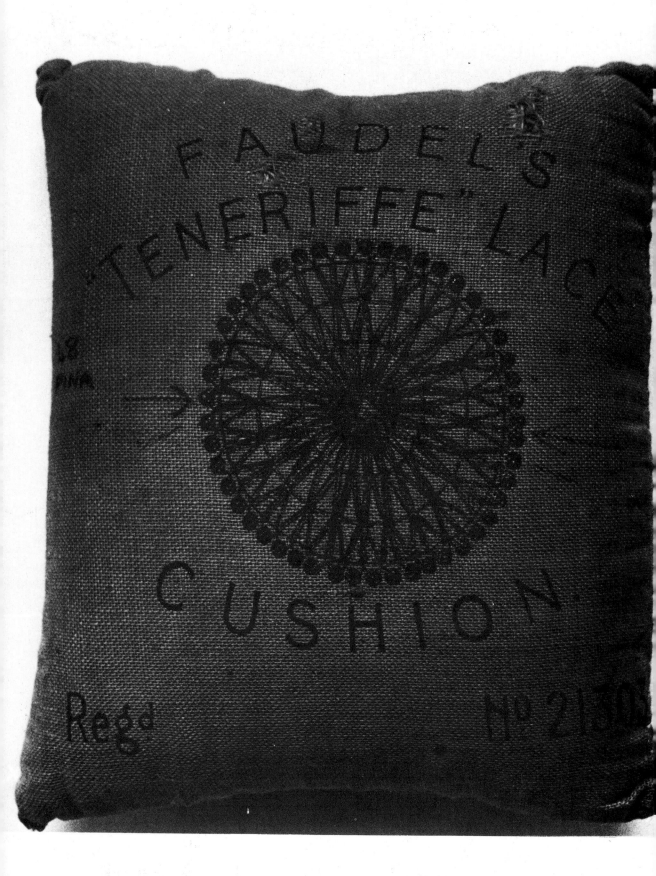

worked round with a needlepoint ground, the network following no proper order but simply working round the design. In flat Venetian Point there is no cordonnette.

Toward the Rococo period the patterns became disconnected, with the relief work falling away until only flat Guipure remained.

One beautiful lace that was produced in Venice was made at the beginning of the eighteenth century; this was the Point de Venise à Réseau. It was made to compete with the laces being made at that time in France and Belgium and it revived all the old traditions and skill of earlier days. The designs, the fine threads that were then being used, the minute stitches and workmanship surpassed all the lace being made in other parts of Europe. Point de Venise à Réseau is different from any other lace because of the little raised knots worked into the pattern and a star-shaped lozenge introduced into the fillings.

The island of Burano near Venice was the principal centre for Argentella. Although Point d'Argentella is attributed to France, there is little doubt that it was made first at Burano. The art had almost been forgotten by the middle of the nineteenth century, but in 1872, after a very hard winter which nearly caused starvation amongst the fishing population, a fund was started by Queen Margherita of Italy. The fund was to help in the foundation of a lace centre. Fortunately, some of the older women could remember the stitches. One old lady in particular had worked the old Burano Point; although she was not able to teach at the centre, she was able to show somebody else how it was done. In a short space of time they were in the position to start a school there and by the turn of this century there were 600 workers either at the school or working from their own homes. Under royal patronage it became the Royal Lace School with its own department for design. Amongst the laces made there were Point de Venise, Point d'Angleterre, Tagliato and one specialist lace known as Point de Venise à la Rose.

A Tenerife lace pillow with a design for a large motif on one side and on the reverse there are patterns for a square and a triangle motif. The overall size for this type of pillow is about 10 cm (4 in.)

Spanish lace

Spanish Point, both raised and flat, is very much like the Venetian Point. One difference is the bride work. Instead of the irregular brided ground of the Venetian lace, Spanish Point has profusely ornamented brides forming part of the design. Pearled coxcombs are a favourite motif along with star-shaped fillings. The designs seem to have been taken from the Moorish embroideries belonging to the Spanish Arabs occupying the areas of the country around Valencia and Andalusia during the Middle Ages. A school of embroidery was established by Philip II in the convent of the Escorial toward the end of the sixteenth century. After the Moriscos were expelled in 1610, the school came under the direction of Fray Lorenzo di Monserrate who used designs taken from the great painters of that time. Scroll work of ornamented fleurs-de-lis and acanthus leaves with trailing stalks were much more artistic than in the Italian laces of the same period.

All the work was done by the nuns, exclusively for the churches, the saints and the priesthood. Beautiful pieces of lace are preserved in the Cathedral of Toledo, where there is a complete set of vestments and altar frontals for every one of the principal feasts of the year.

The only knowledge of Spanish Point was of the pieces appropriated by French officers during the Napoleonic invasion. It was only after the sequestration of the monasteries in 1830 that the valuable laces were cut up and used for dress. At first the value of the lace was not realised but it was not long before the ladies of the Italian and French courts were flaunting it in preference to their own laces.

Real Spanish Point was only worked for a very short period in the seventeenth century and no grounded Point ever appears. With the flat Spanish Point the designs look unfinished; lacking entirely any relief work, it looks straggly and thin, and the designs of the previous laces are completely lost. Whereas before, one worker might take a lifetime working on a particular piece of lace as a gift to the Church or Saint, it was now worked in imitation of that lace by somebody, not even very good with a needle, in as short a time as possible to use for personal adornment.

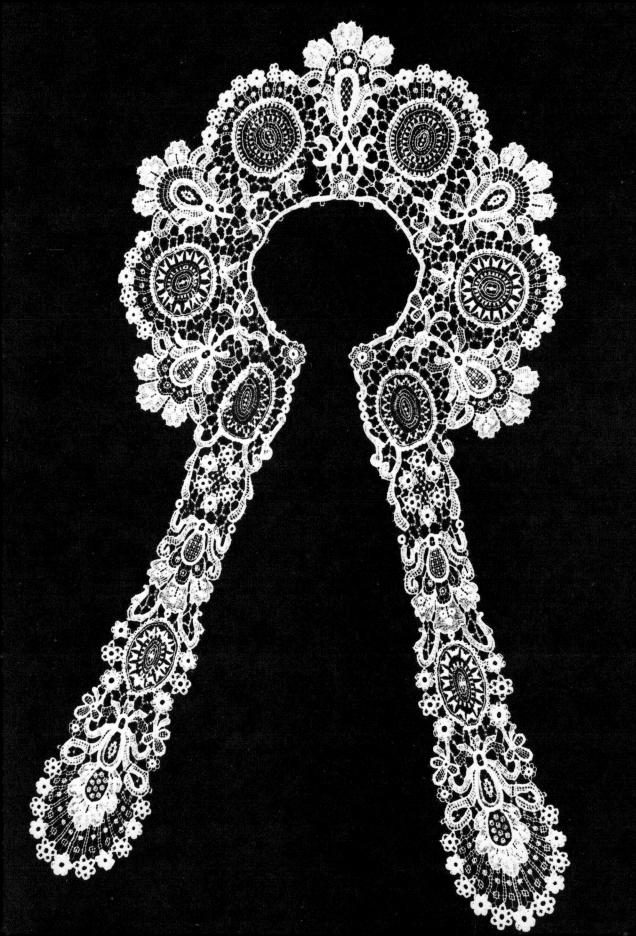

In and around Catalonia much lace was pro-
duced for the mantilla, the national headress of
the Spanish women. Much of the lace used was
the black and white blonde lace. It is not
widely known that a Spanish lady's mantilla is
sacrosanct by law and cannot be taken from her
in exchange for debts even though the mantilla
could be quite valuable. Mantilla lace always
has the design in a heavy thread, while the
grounding is a fine mesh, most of it being made
of pillow lace.

Many gold and silver laces of fine quality and
beautiful designs were made in Spain along
with a special black blonde lace embroidered
with coloured silk. These were in demand for
export.

Sans Sols or Sun lace was very fashionable in
the sixteenth century but this was worked on a
background material. As migrants settled in the
Canary Islands and South America this lace
was worked independent of the material and
became known as Brazilian or Tenerife lace.
The main characteristic of this type of lace is
the way the threads are grouped together in the
centre of each shape and all open up into rays
towards the outer edge. Each shape is worked
separately and then joined to other pieces or
appliquéd to material. This type of lace is now
worked in Spain for the tourist trade.

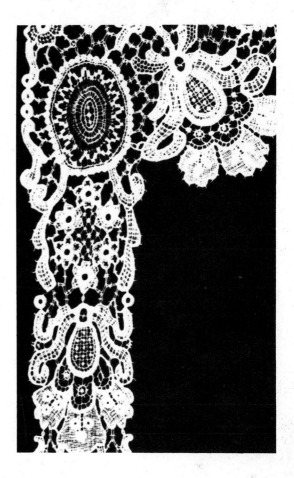

Sans Sols medallions inserted in a collar of Spanish lace
(detail above right)

Spanish Sans Sols lace. The medallions are joined together
with needleweaving (page 28)

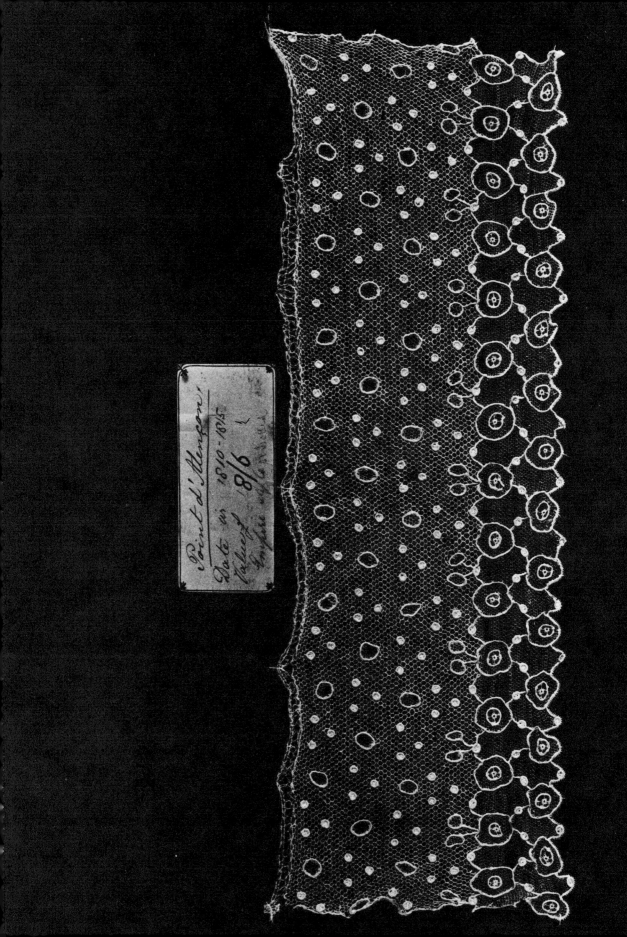

Point d'Alençon
Date: 1810-1815
Value: 8/6

French lace

It has been claimed that lace has been made in France since before the reign of Louis XIV. It was called lacis and was a form of darned netting. But the work was another form of embroidery, popular at this time, and samples show that lengths of lace were made from alternate squares of either cut work or Reticella and netting.

The Reticella laces from Italy were much in demand amongst the ladies of the French Court and huge quantities were imported. Catherine de Medici, the consort of Henry II of France, had patronised the manufacture of lace from the time of her arrival in the country. She invited Federico di Vinciolo, a lace designer, to leave Venice to teach and design exclusively for the French workers.

It was also claimed that Punto in Aria type lace was being made at Alençon as early as 1650. A royal edict, dated 1665, ordered the founding of establishments in favourable districts for the manufacture of needlepoint lace. Alençon and Argentan, both towns in the Department of the Orne, were two of those chosen. This was due to the influence of Jean Baptiste Colbert, the French statesman and chief adviser to Louis XIV. He was determined to stop the large sums of money being spent on the importation of Venetian lace. Repeated sumptuary laws were passed to stop the flow of imported lace, all of which failed. Lace was smuggled into the country one way or another.

It was at Colbert's suggestion that skilled lacemakers as well as designers were brought over. The idea was that they were to teach the French workers Venetian Point, so stopping the importation of the lace. By these means, money that would have gone out of the country was put back into the French treasury.

The Venetian workers were ordered back to their own country. Failure to return meant that the nearest relative left in the homeland would be imprisoned for life. The lace workers had a price put on their heads, but if they returned, work was promised them for life with a 'golden handshake'. The remuneration some received was beyond anything that could have been offered them in France.

By 1669 lace was being made in France that rivalled any made in Italy; it was an exact imitation of Venetian Point. The same designers were being used and the workmanship equalled the original lace. It was virtually impossible to distinguish between the two laces of that period.

The design of the French lace gradually changed and developed a character of its own. The patterns became smaller and more delicate; the use of fine threads enabled the workers to form a more regular tension. The lace was called Point de France, and surpassed the original Venetian Point. The French lace industry expanded so that it became necessary to found another establishment and this was started at the Chateau de Madrid in the Bois de Boulogne.

Because Louis XIV wore his naturally curly hair in shoulder-length ringlets, falling collars went out of fashion. All of his courtiers wore wigs in imitation of the King. Cambric neckties, with ends of rich lace of the heavy Venetian Point type, were adopted. This lace was used for the most unlikely things. Apart from the usual collars and cuffs, men wore lace at the ends of their waist scarves; frills of up to half a metre wide were worn at the ends of their breeches. Deep falling cuffs hung from the tops of their boots and they carried handkerchiefs that were half a metre square which were often made entirely of lace.

The ladies wore lace caps, sleeves, aprons and bodices; their overskirts were heavily trimmed with lace and they used lace fans. Lace was used to cover their bed cushions and the overlaps on their beds. During this period the ladies held receptions from their beds for both male and female acquaintances, so the bed linen was as important to their toilet as was the clothing they wore.

The smuggling of lace across the border between France and Belgium continued right through the centuries. Dogs were used for this purpose at one period. A skin of a larger breed would be sewn over the animal and the space between the animal and false skin would be filled with lace. Coffins were used so regularly for the smuggling of lace that when the body of William Cavendish, the Duke of Devonshire, was brought back to England from France in 1707, not only was the coffin opened and

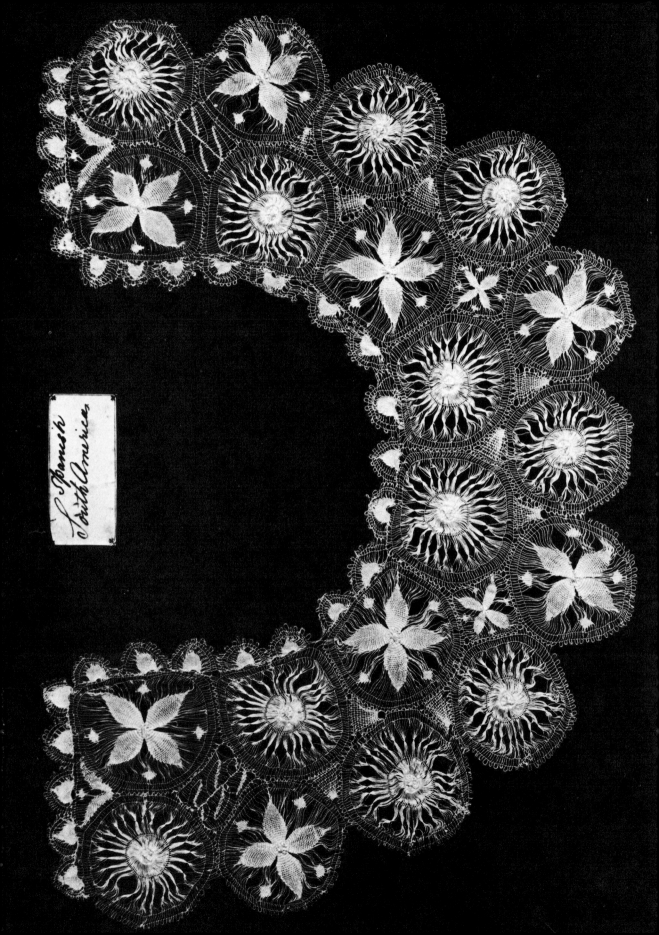

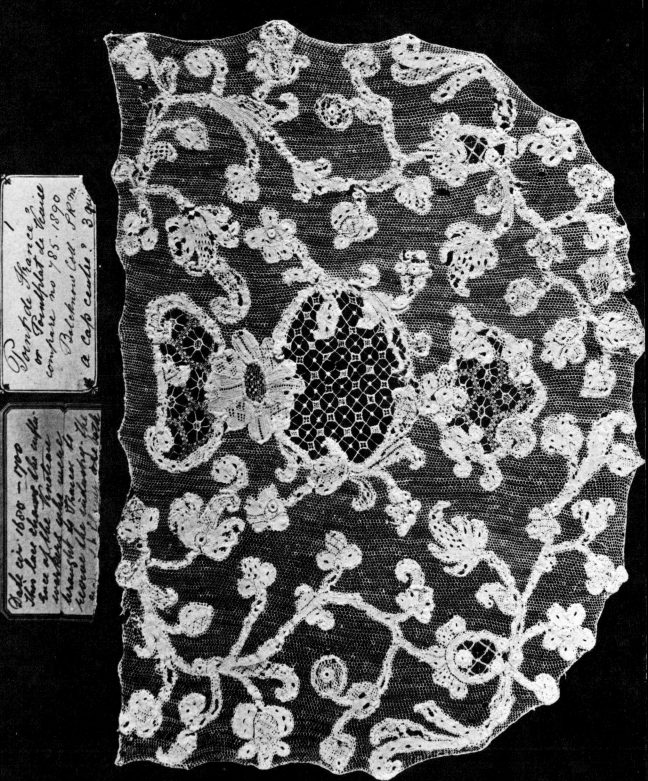

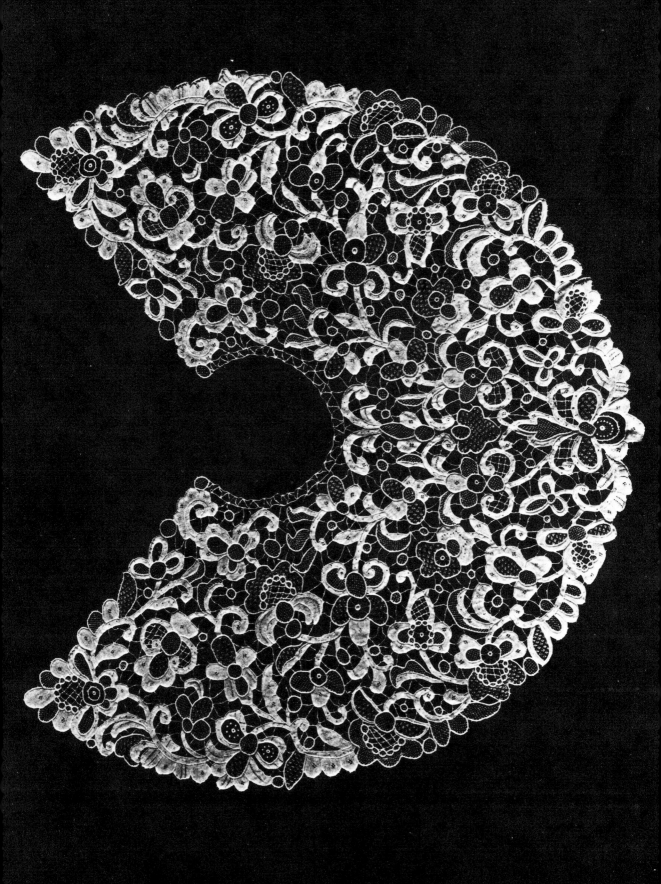

examined but the body was unwrapped for examination as well. £6000 worth of French lace was found in the coffin of Bishop Atterbury, a prominent Jacobite who died in exile in Paris in 1732. Indian servants would carry lace wrapped round their heads under their turbans; false legs had cavities carved out of the centre and lace would be transported inside. The Revenue Officers had a tough time trying to keep up with the ruses thought up by the smugglers.

Instead of fashion magazines, the ladies of the court had a *poupée*, which was a puppet or doll. These fashion dolls were often 92 cm (3 feet) high and were used to display the current fashion in lace and costume. They were made of wood and pasteboard with faces of wax or plaster; many had movable limbs and heads, some even moved by clockwork. The clothes were changed every time a new fashion was introduced. As the rank of the ladies went lower down the scale, so did the size of the dolls. A wealthy lady without a title would have a smaller version called a *Petite Pandore*. All of these dolls were considered so important to fashion that, when in time of war the British ports were closed, special permission was granted for their entry into the country. The lace used on the *poupées* and *pandores* was often worth many hundreds of pounds; the lace that was smuggled through inside the bodies and heads was always worth many hundreds of pounds more. It was almost the end of the eighteenth century before dolls disappeared and engravings were used instead to convey the fashions. The use of the expression that someone 'looks like a fashion plate', stems from those first engravings which were known as 'fashion plates'.

Apart from the lace made at Alençon and Argentan, another was made at Ragusa on the Dalmatian coast. It was called Point de Raguse but it is hard to identify now. Because Ragusa was so near to the Venetian dominions, although not included in them at that time, the lace was very much of the Venetian character. Some claim that it was made even before the Venetian lace. Whether or not that is true cannot be proved but it fetched the same high price, being amongst the most costly of laces, and many workers were brought from Ragusa to Alençon by Colbert. Gold and Silver lace was still being made in the area right up to the early part of this century and some of the patterns being used dated back to the sixteenth century.

During the reign of Louis XVI the Alençon patterns became more naturalistic with roses, ivy and other flowers being represented, and the grounds were sprinkled with dots and leaves. One peculiarity which will always identify Point d'Alençon is the cordonnette of horsehair which is closely covered with buttonhole stitches; it also has a double twist in the réseau. The wonderful delicacy of the grounds and a'jours cannot be appreciated without the help of a magnifying glass.

One lace attributed to France, which is often in dispute, is Point d'Argentella. It has been claimed that it is a copy of the Point d'Alençon made by the Genoese. Whichever is correct it is an exceptionally beautiful lace. The patterns give the widest range of a'jours of any lace, with areas of Mayflower stitch, Lozenge and dotted patterns using all the fillings found in Point d'Alençon.

A very large falling collar with a wonderful selection of stitches, belonging to Kit Pyman. The clothwork design is bold showing plenty of movement, without being fussy (opposite)

Point d'Alençon sections ready to be sewn into larger pieces by the raccroc technique. The outside edges of all these pieces are covered with minute picots. These are so small it appears as a frayed edge in the photographs (page 34)

Alençon lace shown exact size. Sections ready to be assembled by the raccroc stitch (page 35)

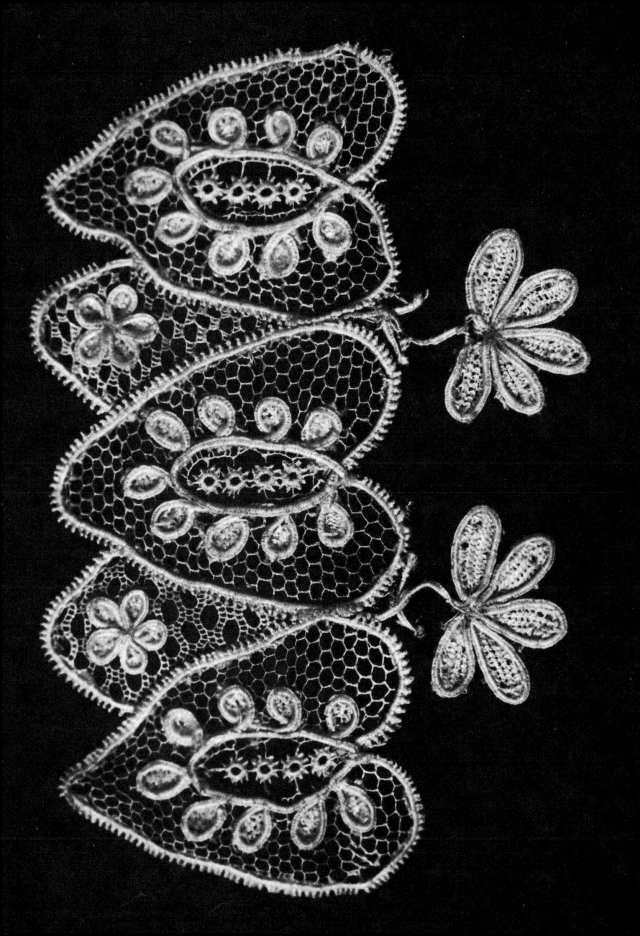

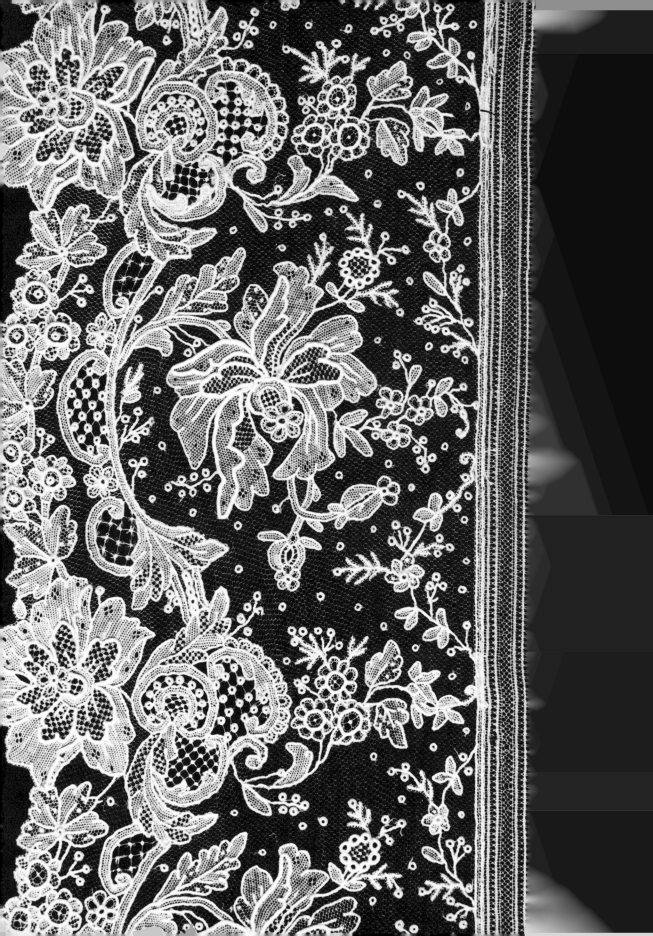

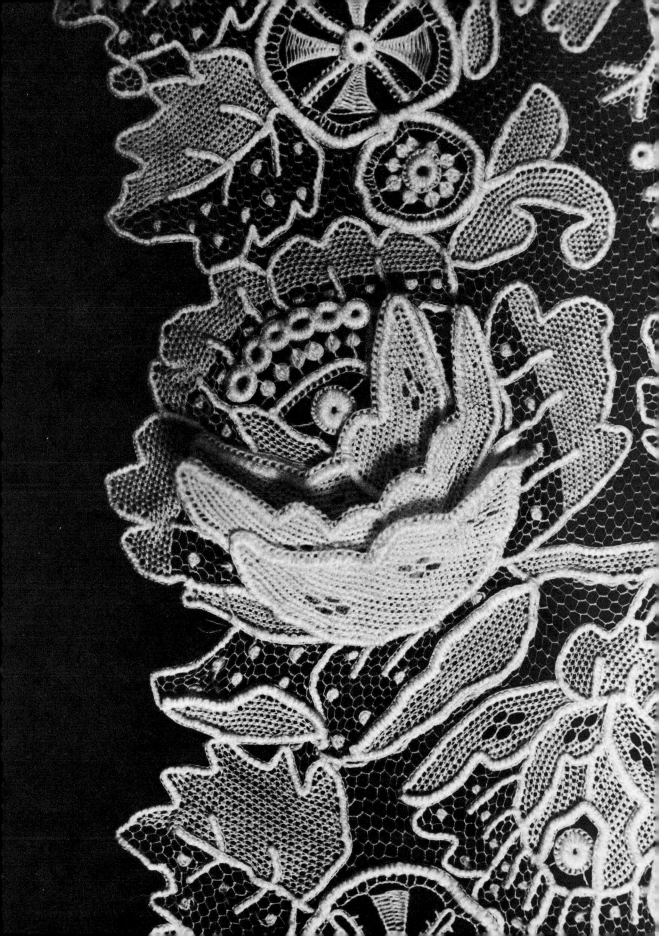

Brussels lace

This city is renowned for its lace, but it is the bobbin lace in which it specialises. The earliest Brussels Point resembles that of Alençon, maybe not so closely worked, and the cordonnette, instead of being entirely worked in buttonhole stitch, is left as a strand of threads. The réseau is made from looped stitches working across in one direction then working back in the other direction, not, as in the case of Alençon, working across in one direction with the buttonhole stitch and then whipping the base of the stitches back to the start of the second row.

The designs used are the same style as the bobbin lace patterns, rarely so fine as the French Renaissance type. Needlemade lace started about 1720 and has always had the mesh type grounds, never with brides as was the early Venetian and French lace. In fact brided needlemade lace samples from Brussels are quite rare. In Brussels, it is claimed that the hand spinners were able to draw from one pound of flax enough thread to make £700 of lace. The thread at one time was fetching £240 per pound. There is no modern machine that can get anywhere near the fine quality of thread that the hand spinners were capable of producing.

With the machine-made nets becoming plentiful, the needlepoint a'jours, instead of being grounded with the needlemade mesh, were applied to machine nets. These nets were made of cotton and shrank the first time they were washed, causing the curves of the a'jours to gather and pucker. Much of this lace was returned to Brussels for cleaning, the whole of the lace being dipped into white lead. This in time turned the whole lace a rust colour causing much of it to fall apart as the threads rotted.

Point de Gaze is a relatively modern lace, the earliest being made towards the end of the nineteenth century. It is made entirely with the needle. It is a lighter lace than its forerunners, being skilfully made, using heavy and light open stitchery in the grounds to give the impression of shading. This lace is made in small pieces, flowers and ground (which is called 'Vrai réseau') being worked simultaneously. The sections are then joined together along a vertical outline of the pattern. The cordonnettes are worked as before, fixed into the outlines by a continuous row of stitches. Often the a'jours are filled with stars and embroidered wheels, while the leaves are sprinkled with small dots.

Point Gaze passes through three stages: the flowers and réseau are made first by the 'gazeuse', the 'brodeuse' places and fixes the cordonnette, the 'fonneuse' works the fancy stitches for the a'jours. The thread that is used for all the modern lace is spun at Ghent.

Point a l'Aiguille is made up of needlepoint flowers and leaves in the same style as Point Gaze, but these are then inserted into Washer's machine-made net. The net is then cut away from beneath the pattern so that the lace looks as if it is all made in one without the appearance of appliqué.

The great variety of filling stitches can be seen in these photographs. It is interesting to see how the small flower sprays along the outer edge have heavy fillings, while the small flower sprays in the mesh have just one round of buttonhole stitch worked over the cordonnet. The ends of the buds are worked in the same way. Rings sprinkled over the mesh are made by running the working thread twice round the six holes surrounding a central hole in the mesh, then working buttonhole stitch over the foundation ring. (page 36)

Three separate petals have been worked in close buttonhole stitch, with four point diamonds. The diamonds are formed by missing stitches on one row and picking them up on the next. There is a row of rings on the back petal, formed by laying the cordonnet in a figure of eight and then covering with buttonhole stitch. Another separate ring is made and joined at the centre of the flower (page 37)

The wheel filling and the wheel garland can be seen in this photograph. The mesh in all these laces is handmade

The medallions are of needlepoint inserted in a Brussels lace berthe (page 40)

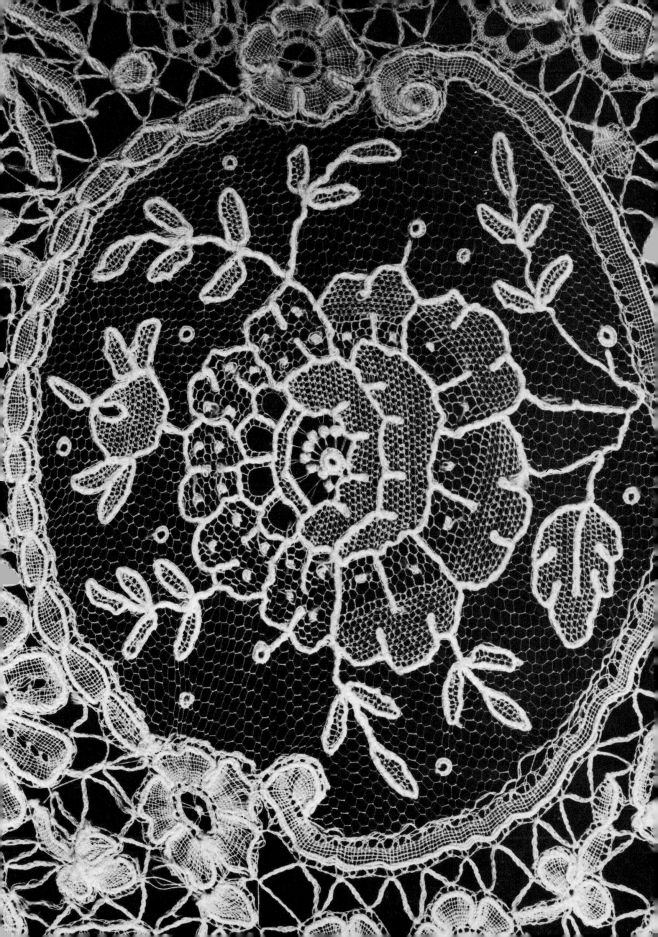

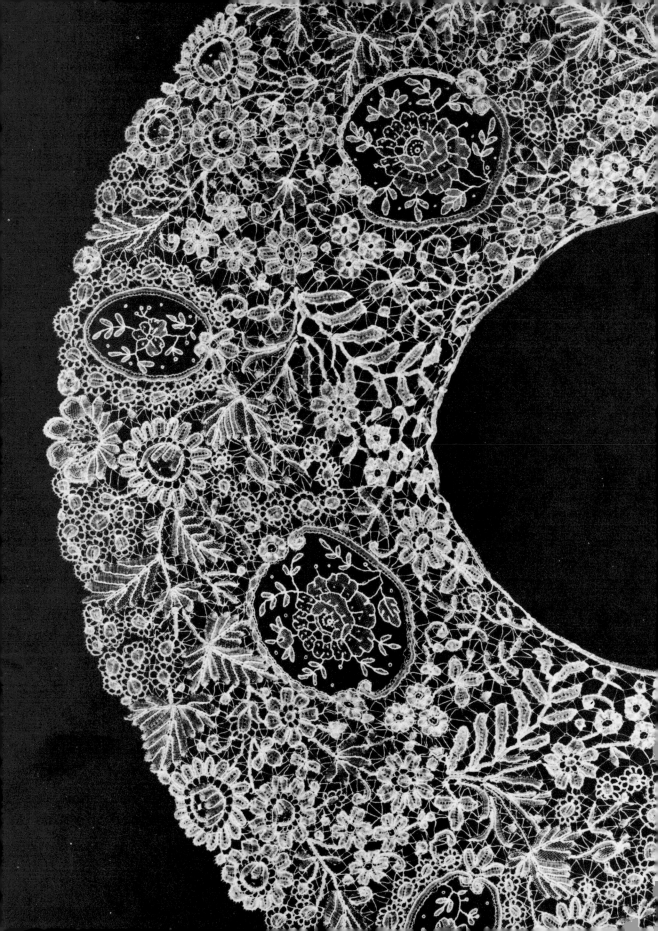

English lace

The first intimation of a new type of needlework being made in England was an account, written in 1454, of a complaint by the women 'of the mystery of thread-working in London in consequence of the importation of six foreign women, by which the manufacture of needlework of thread and silk, not as yet understood, was introduced'. Whether this was the 'Oyah', a crochet work from Turkey, darned net or cut work, will never be known.

There are many accounts of lace before the sixteenth century but the word is used in the broadest sense. One letter, bearing the date 1651, quoted by Alan Cole, mentions women 'sitting making of lace, made by means of bowys'. Bowys was another word for loops. Another account of the same period mentions 'a sampler work, wrought in letters by means of coloured strings and bowys taken from a pattern book, which to know the use of this book, it is two folkes work'. There is every possibility that this refers to finger weaving or braid. Braids were called laces and were used for fastening most articles of clothing and to this day we still use shoe laces. Gold braid on the uniforms of officers in the Services is still referred to as gold lace.

There is a poem by Waller, written in the mid-sixteenth century of a 'Brede of divers colours, woven by four ladies'; the first two lines are

'Twice twenty slender Virgins fingers twine
This curious web, where all their fancies shine.'

Specimens of this type of braid in the British Museum are plaited and stitched together forming an edging closely resembling nine-pin Bedfordshire bobbin lace.

By the beginning of the sixteenth century cut-work had reached a very high standard, as shown by the considerable number of samplers or sam cloths there are to be seen in museums around the country. Most of them were worked in the convents or schools to be used as patterns, and there was a very strong resemblance to the Italian designs of the time. One sampler at the Victoria and Albert Museum, London, has bands of embroidery inset with cut work that measures almost one and half yards in length. It is signed and dated 'Elizabeth Mackett 1696'.

Tradition is that while Katherine of Aragon was staying at Ampthill in Bedfordshire from 1531–1533 she taught the ladies of her household bobbin lace. But the lace made in Bedfordshire at that time was not bobbin lace. It is more likely that as Katherine was an acknowledged needlewoman it was the linen cut work and the Reticellas, that were of such high standard in Spain during the period, that she would have taught.

This is made more certain by the fact that Bedfordshire specialised in 'seaming' and 'spacing' lace, which were bands of cut work. These were used to join two pieces of linen together instead of a seam. This method was used from early Elizabethan times until late in the nineteenth century.

It was some thirty years after Katherine, in 1568, that the Flemish refugees arrived in the area after fleeing from the persecutions of the Duke of Alva, bringing with them the techniques of bobbin lace. The earliest mention of bone lace was in 1554 when it was said that it trimmed the dress worn by Sir Thomas Wyatt at his execution. By the time of the accession to the throne of Queen Elizabeth I, lace made on the pillow was constantly being referred to.

In 1685, another immigration of foreign lace-makers took place; this was after the revocation of the Edict of Nantes and it was from the French provinces bordering on Flanders. There is no doubt that the Flemish character of Bucks lace can be attributed to the influx of these workers. It was at this point that the needle-made laces, whether cut work, Reticella or netting, took second place to the bobbin lace.

A form of needlepoint lace was worked in Devon from early in the sixteenth century and with the arrival of the refugees from the continent during the second half of the century, the lace acquired a distinct Flemish style. It was worked under the name of Point d'Angleterre, and it is claimed that it was exported to France and Brussels. Claims have also been made that, on the contrary, the lace came to England from Flanders. Be that as it may, the fact is that very high-quality lace was made in the country until the end of the eighteenth century. Devon, like other parts of the country, found bobbin lace to be a better financial proposition and it is the beautiful sprig laces identical to the Brussels

lace that it is renowned for. Before the introduction of machine-made net the pattern of Honiton lace was worked on the pillow, the ground being worked of needlepoint mesh.

The county of Dorset was another area where needlepoint lace was made. At Blandford a Point Guipure was made, in the style of early Point de France, that commanded very high prices.

In the Anti-Gallican Society records of 1751 a prize for needlepoint ruffles was awarded to a Mrs Elizabeth Waterman, of Salisbury. It would be difficult to prove whether this was true needlepoint or bobbin lace of a very high quality. During one period any lace, regardless of how it was made, had the tag of needlepoint if the workmanship was of an extremely high standard.

English needlewomen certainly excelled in some of the Points of the seventeenth century; a lot of the work was of the Reticella type. The only characteristic of English Point is the thread, which was of a natural colour and coarser than that used on the Continent.

Patterns were given for Point lace in a new book written by John Taylor, the Water Poet, called 'The Needle's Excellency', printed in 1640. It is the only book published in England on the art of needlework, lace and embroidery at so early a date. English needlemade lace is generally acknowledged to have been at its best in the seventeenth century.

Hollie or Holy Point was used for large quantities of Church work. This is one of the few needlepoint stitches to have been credited to English origin. The correct definition of Holy Point is a needlepoint lace, but the term has been used to denote Church work of any kind, whether it was darned netting, cut or pulled work, or the detached lace stitch. The lace was not exclusively worked in England; samples have been found in Italy, Spain and Flanders. The stitch is worked in close formation in one direction only, the thread being then taken back across the bottom of the loops to start the second row. The pattern is formed by skipping stitches on one row and picking them up on the next. For this reason the result resembles crochet work. During the nineteenth century crochet was called Hollie Point. The blocks of stitches and the surrounding holes adapt easily

to lettering, numerals and symbolism. Most of the commonly-used motifs appear to have been culled from designs drawn specifically for crewel work, which included the fleur-de-lis, animals and geometric patterns. After the Reformation, when the despoiling of the churches had taken place, all the Holy Point lace was cut up to be used for personal and household items by the Puritans. Hollie Point became a term to denote any crochet or net work instead of the rich needlepoint that it once had been.

About 1800, embroidery on muslin came into fashion and struck a severe blow at handmade lace. When machine-made net reached the market, matters became even worse. Cotton thread was first used in place of flax in 1831, with dreadful results, because of the lack of durability of the lace produced.

Queen Victoria gave enormous orders for her trousseau and later for those of her daughters, but there were not enough workers capable of making the fine needlepoints. There was a marked deterioration of design and within the space of fifteen years needlemade lace became almost extinct.

At the beginning of the twentieth century the two Tebbs sisters opened a School of Bobbin Lace at 14 Upper Baker Street, London. In 1913 they published a book called 'The New Punto Tagliato' and offered classes for this revived lace. After the First World War they moved to Church Street, Kensington, in London and the author was taken to some of these classes as a very small child. The only recollection she now has of the place is that at four o'clock the lace was put to one side while the ladies were plied with tea and cream cakes. The small child was not allowed the luxury as her hands would have become sticky, which never did make sense because she was not making lace anyway. Time was spent sitting under a little table, hidden by the deep lace flounce round the edge of the tablecloth, making faces at herself in the pointed toes of the ladies' patent leather shoes!

The sisters won gold medals at the Philadelphia Centenary Exhibition in 1875 plus other awards at numerous exhibitions at home and abroad. The school was extremely successful and had a prize at the Franco-British Exhibition in 1908.

Louisa and Rosa Tebbs did much to keep

handmade needle lace from becoming extinct when the machines killed the trade by making lace the 'in thing' for ladies to do. With magazines such as *Hearth and Home*, *The Queen*, and *The Lady* all carrying glowing accounts of the 'new delights' and the 'most fascinating varieties of the new fancy work', needlepoint lace was no longer a labour for survival for the poor; it was a labour of love for monied or bored ladies. By 1920 the school had expanded to other premises in Eastbourne as well as the Kensington Church Street School.

Women's guilds and organisations kept Tagliato alive until the Second World War, but from then on it seems to have disappeared. Bobbin lace has gone through a terrific revival over the last twelve years. Perhaps this book will generate the same interest in the needlepoint laces.

Coggeshall lace

Tambouring was a form of embroidery of Eastern origin and was introduced into this country by a French emigrant and his two daughters in 1812. They settled in Essex, and started the first factory or school for teaching and producing Tambour lace in the small village of Coggeshall.

Eventually many more tambour 'rooms' were set up in the area between Colchester and Braintree. Although the lace was extremely popular it was never given a specific name, which is a great pity. This book will go a little way toward rectifying that mistake because the name of the village is the heading under which it is being placed. Tambouring is embroidery, worked with a hook, the result being a chain stitch. Coggeshall is tambouring worked on a net foundation, usually white on white, giving a lace effect; not needlepoint lace in the true sense, but lace nonetheless.

The tambour hook is like a crochet hook with a much sharper point which curves in toward the back of the shank. This allows the point to pierce the material easily; it also allows the hook to be withdrawn without tearing the material. The hook is made in sections; a handle and different sized hooks. The handle resembles a watchmaker's vice, with a screw at the base. This has a twofold purpose; first, it enables the hook to be removed when a different size is

needed; secondly, the screw stops the hook from passing too far into the material. This prevents the sharp point from piercing the finger that guides the thread under the material.

With crochet the hook is held horizontally and the hook picks up the thread, whereas with tambour work, the hook is held vertically and the hand under the work places the thread round, and into, the curve of the hook.

The materials needed to work this lace are easily obtainable and, once the knack of holding the hook and feeding the running threads is acquired, the work proceeds quickly.

Coggeshall lace is worked on nets with a round-hole mesh; a special net is available from the same supplier as that given for the tambour hooks.

The net is held taut in an embroidery frame; the round ring type of frame was, and still is, called a tambour frame. The square slate frame is a better proposition if working large areas.

Perlé and Coton à Broder can be used for outlining the designs, while a finer thread is used for the fillings.

A finger shield should be worn on the forefinger of the hand guiding the thread under the net to avoid tearing the finger with the constant movement of the hook. It can also be used to apply slight pressure to the material as the hook is withdrawn through the net.

The design is drawn on paper and laid under the net; the worker then follows the design freehand. If preferred, the design can be etched onto the net with white gouache paint using the finest paint brush possible.

A sample piece of tambour lace worked by the author, showing the chain stitch that is the hallmark of this lace (page 44)

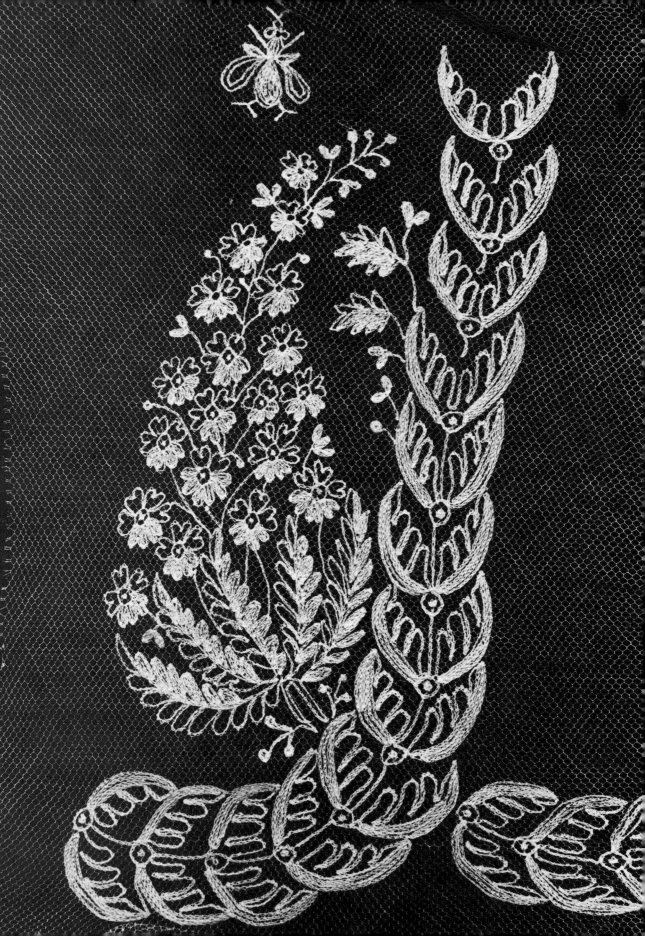

Traditional Irish laces
Carrickmacross

This lace is appliquéd muslin on net; when the design is attached, the excess muslin is cut away.

Carrickmacross lace is the oldest of the needle-made laces of Ireland. It started about 1820 in the small parish of Donaghmoyne, not far from the town of Carrickmacross in County Monaghan. A Mrs Grey Porter taught her maid, Mary Anne Steadman, to make a type of lace that Mrs Grey Porter had acquired from Italy. Mary Steadman became so skilled that her reputation as a lace maker led to many of the wealthy ladies of the area placing orders with her and asking for tuition.

One of these ladies, a Miss Reid of the village of Rehans, after receiving tuition for a while, became one of Mary's prize pupils. In a very short time she was in turn teaching her own sister Dora, and between them they established a school by converting a barn on their brother's farm. It was so popular that the premises soon became overcrowded and the two sisters had a school built on their own land. Soon they were in the position to employ a number of workers and orders for the lace increased until it became a thriving business.

As this was a farming community with no other industry in the area, the money made by these workers helped the family income considerably and when, twenty-five years later, famine again hit the country because of crop failure, the only income for some families was that received from the lace school.

At that time a local councillor, Mr Tristram Kennedy, realised the possibilities and applied for a Government grant. This he received, and with it he built seven schools in and around Carrickmacross. Another councillor, Captain Morant, gave the use of one of his houses for the administration of the schools and as a collecting point for the lace. It was to this house that designers were brought over from England to teach design and supply the schools with new patterns. Up to this point all the work had been based on the Italian style that Miss Reid had first taught.

By 1850 all the schools were built and well established, and in 1852 Mr Kennedy entered

The true needlepoint lace from Ireland with a brided ground, possibly from County Monaghan. The band of bobbin lace can be seen running along the top of the lace (page 46)

A Carrickmacross collar, belonging to Gillian Elliot, showing the typical trails found in so much of this lace. There are four picots to each flower that borders the neckline, and continuous picots round the outside edge all of which are handmade (page 47). Detail shown on page 48

Parliament. While living in London he interested many local traders in the work. It was brought to the attention of Queen Victoria who gave orders for large pieces of lace both for herself and her daughters. The schools' finances were hit many times during their existence but by 1893 the Countess of Aberdeen became very interested in what was happening in the schools. It was her influence that put Carrickmacross Lace on the map. From then on two distinct types of lace were produced in the schools. One was appliqué, the other became known as Irish Guipure. The first was formed by a design in muslin being applied to a net background, while Guipure was embroidered muslin, held together with bars. Sometimes old pieces of lace are found where both techniques have been used together with very beautiful results.

Limerick lace

Limerick lace received its name in the same way as Carrickmacross lace, being the name of the town in which it was worked. Both laces rely on a net background. But there the comparisons end, at least for the first fifty years of its existence. Carrickmacross lace was brought into being by a group of philanthropic ladies, aided by a benevolent local government. Limerick lace was a commercial venture from the start.

Mr Charles Walker was an Oxfordshire man who had every intention of entering the Church. Although he was always known as the Reverend Walker he was never more than a divinity student. He married the daughter of a Nottingham lace manufacturer, gave up his studies, and any thought of entering the Church was forsaken in favour of becoming a lacemaker. In the year 1829 he and his wife settled in Limerick and, with a number of lace workers brought over with them from England, set up a factory for the production of hand embroidered

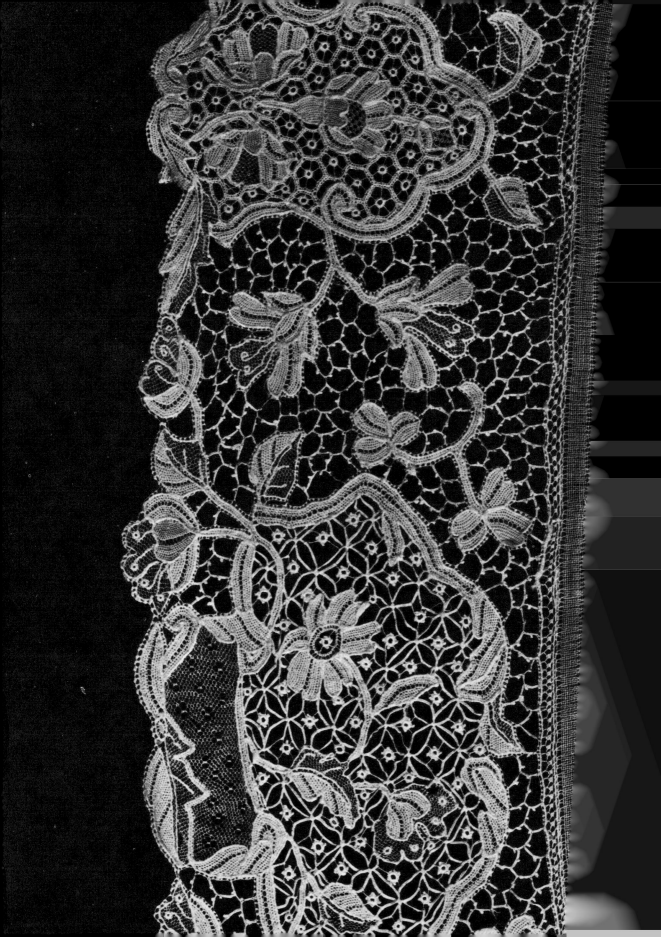

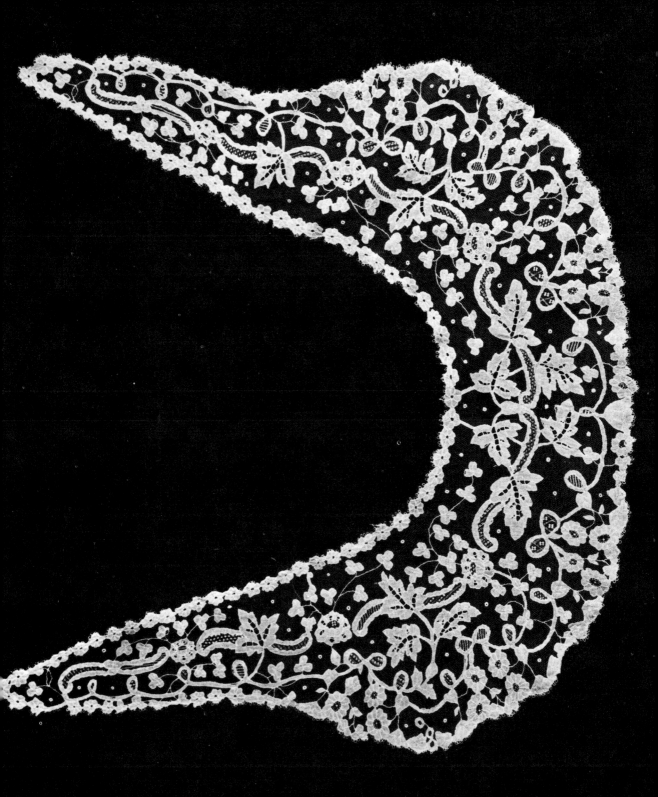

machine-made net. It was a very successful venture employing hundreds of women and girls in the neighbouring districts as well as the large workforce at the factory. For the first thirty years it was a flourishing business. By the end of fifty years the trade had suffered a recession that caused it to practically die out in the area, while the lace still made degenerated both in design and execution.

Limerick lace then followed much the same pattern of events as that of Carrickmacross. Mrs Vere O'Brien formed a group of educated ladies whose aim was to bring in new designs and to improve the workmanship of the women still making the lace. By the turn of the century Limerick lace was back to its finer glory and remained so for a number of years.

Mrs O'Brien is credited with the designing of net appliqué. This is worked in the same way as Carrickmacross using two layers of net instead of muslin and net.

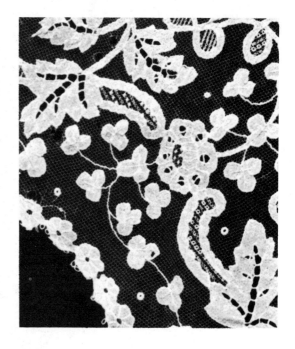

German lace

Dresden, Freiberg, Hamburg, Nuremburg and Fürth were the centres of both bobbin and needlepoint lace. Most of the lace made there was an imitation of the Brussels Point, although at Nuremburg much lace of the Venetian style was made. Several pattern books were printed and published.

Germany was another country to benefit from the influx of refugees. Other towns in the north, such as Leipzig, Halle and Hanover, all had lace centres but little is known about the character of their productions. Much lace was bobbin made; the probability is that Germany passed through the same stages of lace making as the rest of the continent. As the French refugees scattered through the area, so they taught the communities how to plait silver and gold thread into galloons and vandyked borders for the court and military costumes.

Workers from Dresden, although famous for their fine muslin work, also produced another form of needlemade lace. It combined net embroidery worked in microscopic patterns that must have been as laborious as real needlepoint. This was known as Dresden Point; the earlier gold and silver work was known as Hamburg Point.

However, the German pattern books of this period contain no instructions for the making of needlepoint except for a few copied from the Italian book, and if any was made there it was insignificant and never recorded.

There was another lace made in Germany that does not come under the heading of bobbin lace, but the amount of needlemade stitches that were used to put finishing touches to this lace would hardly qualify for the name of needlepoint either. This was the caterpillar lace. Ground mulberry leaves, flour and water were mixed to a paste. This was spread over large stones and a lace design was blocked out on the paste with oil. The caterpillars were then put at the base of the stone and left to eat their way through the unoiled parts of the paste.

The strong web that they spun connected the uneaten parts of the design. It is presumed that the caterpillars used were the silk worm from the Bombyx Mori moth. This caterpillar has twin tubes, one on each side of its head, which are called spinnerets. Through these tubes the caterpillar exudes a viscous protein in the form of a thread that solidifies as it comes in contact with the air. We call the secretion silk; it has a strength out of all proportion to its weight. The lace made by this process must have been very fragile; many accounts are written about caterpillar lace but specimens are few.

According to the tombstone on the grave of Barbara Uttmann, lace was invented in Germany. It states 'Here lies Barbara Uttmann, died fourteenth January 1575, whose invention of lace in the year 1561 made her the benefactress of the Hartz Mountains'. Barbara was born in 1514 to the patrician family of the Etterlienes in Nuremburg; she married a rich miner from Annaberg named Christopher Uttmann. They soon became acquainted with the women of the mining population and realised how important it was for the women to add to the meagre incomes of the men. Barbara took the Treillis d'Allemagne nets made in the area since the early part of the sixteenth century and elaborated on them. She had been taught bobbin lace by a Brabant Protestant, banished by the Duke of Alva Treatise, and this skill in turn she taught to her pupils. The new industry grew so rapidly that she established a factory in Annaberg for the issue of patterns and the sale of the work produced. By the time she died, bobbin lace was a thriving industry and remained so for three centuries.

It is not known for certain how much of the net embroidery continued to be made once the women realised that they made more money by producing the quicker-made bobbin lace.

Two pieces of lace from Germany, both from the Dresden area, about 1885. The muslin work which measures 6 cm × 7.5 cm (2½ in. × 3 in.) is so fine that at first glance it could be mistaken for Carrickmacross. The second piece is nearly 10 cm × 13 cm (4 in. × 5 in.) composed of pulled fabric and drawn thread work. As the filling stitches are so fine a magnifying glass is needed to appreciate the work (pages 50, 51)

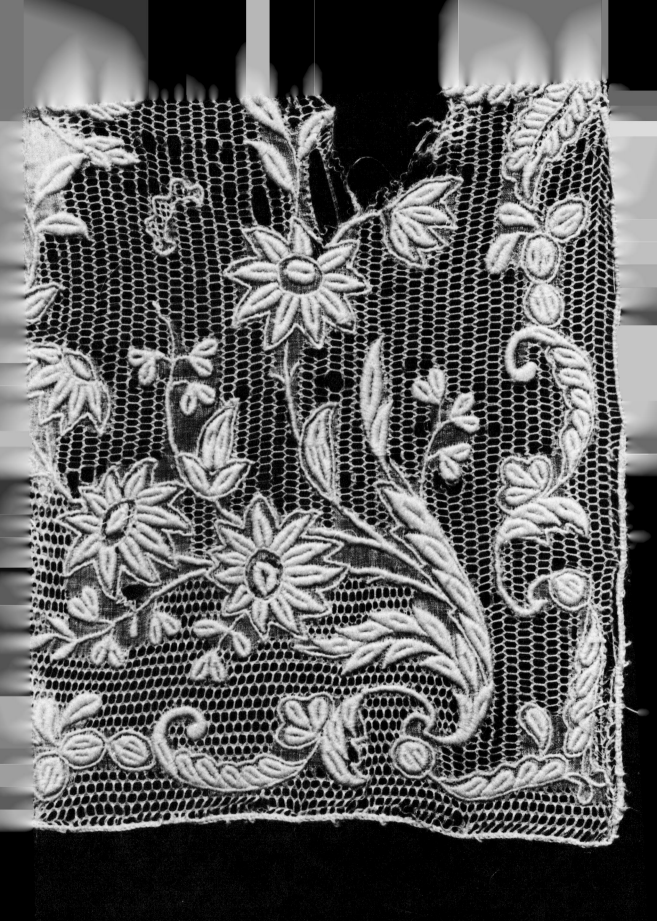

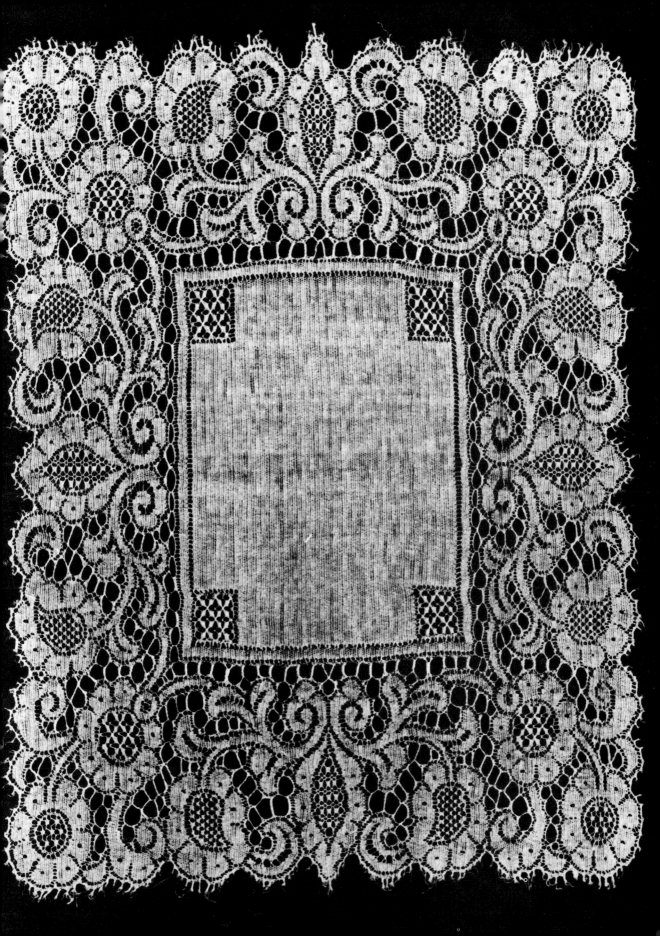

Danish lace
Hedebosyning

Translated literally, Hedebosyning means Hedebo sewing. Hedebo is traditional Danish whitework embroidery which was made in vast quantities by the women and girls of Hedan. This is a large district of heathland between Roskilde and Copenhagen. Hedan translates into 'heath' and 'bo' means to live; Hedebo embroidery was worked by the people who lived on the heath.

The original embroidery took the form of surface stitches, mainly chain stitch, enclosing the conventional floral shapes which were cut away or filled with drawn-thread stitches.

By the middle of the nineteenth century the Reticella of Italy was being introduced. This was in the form of squares which were cut away from the material, and the Reticella squares were sewn into the spaces; the character of the work became geometrical and formal. Many of these old specimens are now in the museum of Copenhagen. In those days mothers prepared masses of household and personal linen for the marriages of their daughters. The time spent on spinning and weaving the fine linens, and the making of the lace to ornament it, took almost all of their lifetime. It is little wonder that a good deal of it is still handed down from generation to generation. When worked on good linen it is a very strong form of lace.

From Hedebo embroidery, holes are cut in the material and the edges turned in and buttonholed. The shapes are kept simple and consist of circles, squares, lozenges, shields, hearts and floral motifs. These are then filled in with lace stitches. Surface embroidery surrounds the cut work which increases the rich effect.

Hedebosyning is made independent of any background material, and samples of charming edges and motifs can be worked out on graph paper. One of the advantages of this work is its adaptability to modern fashion.

High prices can still be demanded for even small articles and it is certainly in the 'collectors' bracket. It is not difficult to work; practice gives the right tensions and spacing which are the hallmark of all good lace.

DESIGNING

As there are no designs for needlepoint lace available, the worker will have to draw her own. The usual response to that statement is one of horror, every other student is quite convinced that she is unable to draw. This chapter is a light-hearted approach to the subject, showing a number of ways of getting a design on paper, without actually drawing freehand.

Anyone can draw a squiggle or an S bend, and that is all one needs. The only requirements are a roll of greaseproof paper or tracing paper, pencil, rubber, set square and a rule.

We will start with traditional shapes as these are the easiest to manage. Most of the early

Part of a muslin flounce, the property of The Royal School Needlework. Shadow work and a number of different drawn fabric stitches have been used as fillings on the muslin to form the design. The interesting thing about this flounce is the way each of the flowers has raised needlepoint petals attached. This can be seen very clearly in the sprays (page 56)

The small spray would make an ideal subject to start as a project using fine thread (page 57)

designs were made up of scrolls, sometimes coiled or curved, sometimes in the form of spirals. The basis of a scroll is an elongated S shape, ending with a circle or a bulge. Two identical scrolls placed face to face can make a design and it is on this basis that the designs will be formed.

The basis of all scrolls – an elongated 'S'

The 'inside fluted line' added

The added line along the side of the 'S' making the enlarged scroll

Two ways of adding the enlarged scrolls to the original design

The mirror image

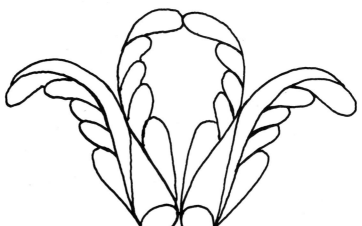

55

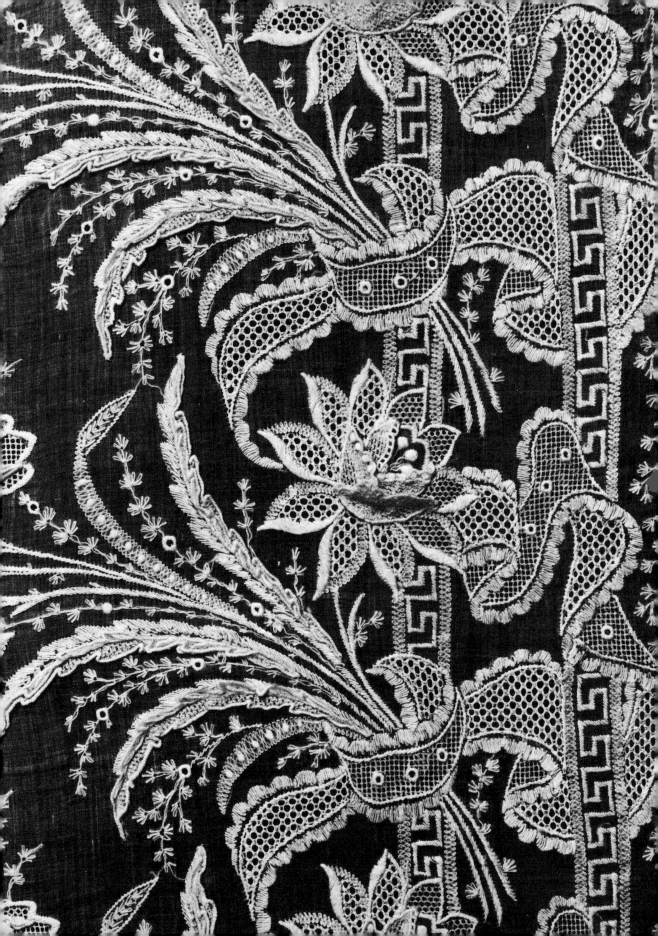

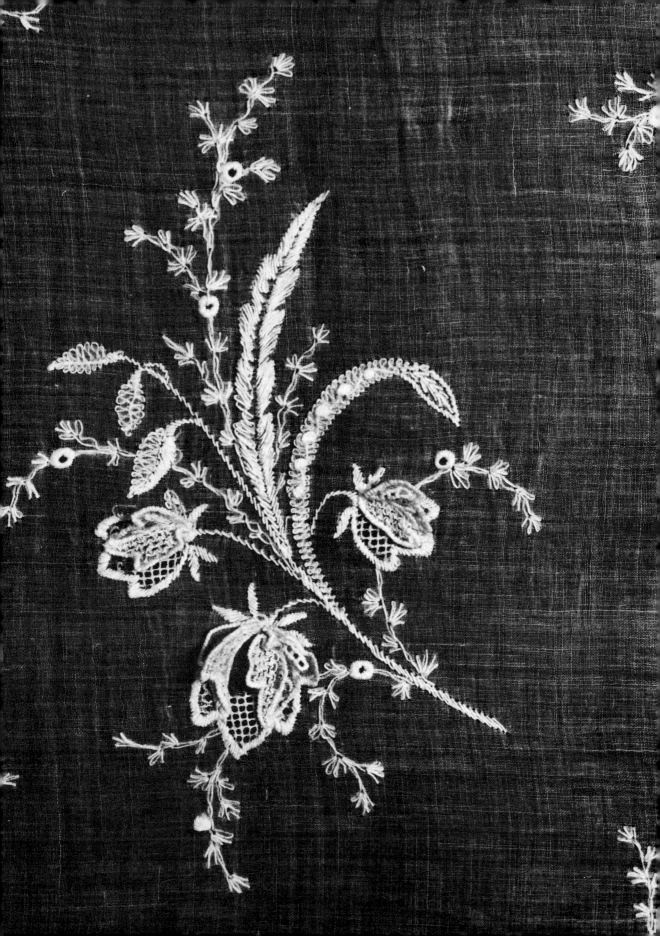

Follow the drawings carefully, starting with the elongated S and joining up the tail. Draw two or three different shaped S's until finding one that appeals. Place the drawing under a sheet of greaseproof paper and re-draw.

Draw the inside line to form a scroll, fluting the line until reaching the base of the first drawing and then merge into the bottom of the S.

Place a rule from the tip of the S to the edge of the base of the scroll and draw a feint line. Fold the greaseproof along the line and re-draw the complete scroll. This will give a mirror image and form one complete motif.

Enlarge the scrolls by re-drawing the original and adding a curve to the outside edge, starting off at the tip and ending at the base of the curve before it enters the circle. Draw a mirror image of this enlarged scroll and lay one each side of the first complete motif. Depending on which way the second scroll is laid, a closely-packed or more flowing design can be achieved. Draw up as one complete motif.

Various shaped scrolls added to an asymmetric oval

Flower motif

Draw an asymmetric circle, add a base, making it look like an ice cream cone. Add this shape to the original scroll and join together with either another smaller scroll or a curve. The resulting motif will be typical of the designs found in seventeenth-century lace, before the natural floral shapes became popular.

Use this idea to build up an abstract flower motif; avoid a too naturalistic approach. Draw the flower shape; this can be quite rough at first to get an idea, then lay a second piece of greaseproof over this shape and improve on it. When satisfied with the design, lay the drawing of the enlarged scroll alongside the flower shape, placing the tip of the scroll against one of the petals. Arrange and re-arrange until satisfied, then lay another sheet of greaseproof over the top and draw the flower and the scroll. Now join the two motifs together with a curve, in the form of a stalk. Draw this motif in reverse by turning the greaseproof over and taking a second tracing from the back of the first drawing. Cut out both motifs and re-arrange to make either borders or corners.

See overleaf for more flower motifs

Reverse patterns

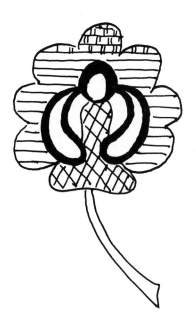

Repeat patterns

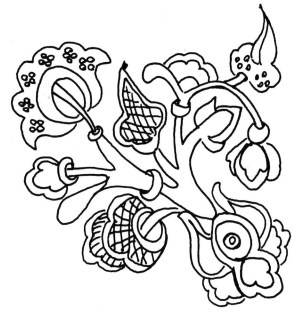

Left
Draw a reverse of the flower motif by laying greaseproof paper over the first drawing, trace off, then turn the greaseproof paper over and use the reverse side

The same flower motif rearranged to make three different designs

63

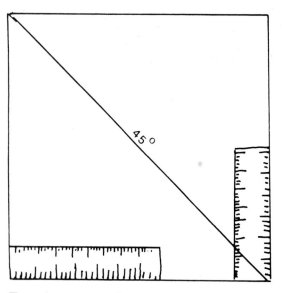

To make a pattern for a corner, the design will
need to be placed at a 45° angle. Draw a square
measuring 200 mm (8 in.) (this is the usual size
for a lady's handkerchief) then draw a line from
the top left-hand corner to the bottom right-
hand corner. The resulting line is on a 45° angle
and two motifs on this line will give a corner
design. It will not cause any problems if the
outside of the design extends beyond the edges
of the square. It can make a fluted corner to
the handkerchief or the inside line may be ad-
justed to bring the two separate motifs closer
together. It is often easier to erase a line to keep
the flow of the design than to add extra lines.

PREPARATION

The pillow

It is much easier to work the stitches if both hands are free to manipulate the threads. For this reason a round bolster-shaped pillow to pin the work to is an advantage. These pillows can be purchased (see list of suppliers at end of book) or can be made from the type of tin used for babies' dried milk food, or dried potato mix. Fill the tin with dry sand to give added weight, replace the lid and wrap the tin in layers of wadding. Make sure there is enough depth to the wadding to allow for the insertion of pins. The diameter of the pillow needs to be about 16 cm (6 in.).

Sew or tie the wadding in place, making sure it is tightly packed round the tin. Now make a cover with a piece of dark-coloured material, allowing 3 cm (1 in.) overlap each end. Run a line of small tacking stitches round each end to draw up and fasten off securely. Cut two circles of the material to fit top and bottom of the tin and turn under a small hem, then sew to each end.

Cover the tin with a dark material to avoid eye strain

Base fabric

Needlepoint lace is made up of detached stitches, worked over a foundation thread called a cordonnet, which in turn is stitched to a fabric background.

Originally the design was traced on chamois leather or kid which was then laid over parchment. The cordonnet was stitched to both layers. This accounted for the work of three people – the person who traced the design, another who pricked the holes through the leather and parchment, the third who couched the cordonnet to both layers.

With the use of PVC sheets, as used for overhead projection, and a piece of glazed cotton or denim, the process becomes much easier.

Polyvinyl chloride sheet can be purchased at most drawing office suppliers. It comes in the form of coloured transparent film, one side being adhesive.

First draw or trace off the design, then cut the PVC to size and remove the protective backing. Carefully stick over the design.

Take the material, which needs to be a little over twice the size of the design, and fold in half. Lay the prepared design on top of the folded material and tack together.

Needles

Tapestry needles have round blunt points and are best for working all the lace stitches; use No. 25 or 24. If using Perle No. 8 or No. 5 for Sans Sols or Tenerife a No. 24 will be needed. For laying the foundation thread or cordonnet use a No. 8 Crewel needle, which has a long eye and a sharp point. This size needle will be needed for Carrickmacross also.

If an ordinary sewing needle has to be used for the lace stitches the point would be constantly splitting the thread, so the needle must be used eye down with the point against the thimble. A Chenille needle is useful for taking the foundation thread through the fabric.

Threads

The threads used will depend on the scale of the design being worked. It is advisable to work samples of all the stitches before attempting a piece of lace. Work the samples in 5 cm (2 in.) squares with a crochet cotton No. 60 for the stitches and coton-à-broder No. 25 for the foundation thread. The large design on page 68 is meant for working in threads of these sizes

Once the working methods are appreciated the stitches can be worked in the finer threads. All crochet cottons work well – 80, 100, 150 are all suitable for needlepoint lace. There are

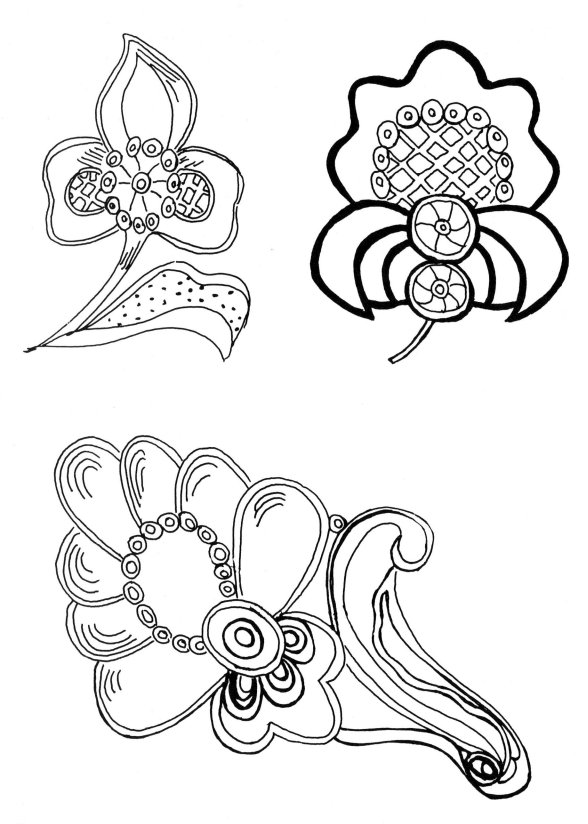

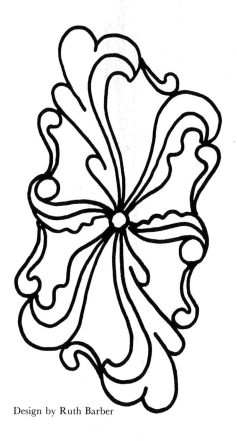

Design by Ruth Barber

Hedebo Would be worked with the same threads as Sans Sols.

Limerick For outlining and darning, use DMC Lin Floche and Fil à dentelles and DMC Alsatia for the fillings.

Fil à dentelles is a 6-cord thread; Lin pour dentelles is a flax lace thread. The cotton gives a softer handle to the finished work, while the flax has a sheen to it and holds its shape well. It is advisable to have a selection of threads, to be able to choose the right thread for the scale of the design. No two people work to the same tension and what might suit one person would not necessarily be right for another.

Fill de Trace

Originally the parchment was pricked with two parallel holes placed close together in series, to cover the whole of the outline of the design. White paint was then rubbed into the holes to make them more distinct.

Stitches were then made, bringing the needle up from behind the parchment, through one hole, over and down through the hole opposite. The thread was taken along the back of the parchment to the next pair of holes, where another stitch was made in the same way. The whole of the design was blocked out in this manner.

The foundation thread was then taken through these small stitches. When laid in this fashion the foundation thread can be run in over the same place twice, without having to cut the thread to start a new run. Fill de Trace is another way to work the couching.

specialist threads for each type of lace; the following list suggests some of them.

Venetian DMC Lin pour dentelles and 150 crochet cotton.

Alençon DMC Alsace 60.

Sans Sols or Tenerife DMC Lin pour dentelles No. 40 or DMC Alsatia No. 40.

Laying the cordonnet

Use two strands of coton-à-broder and couch round the design in one continuous length if possible. A little forethought will often help in seeing a way round the whole design without cutting and rejoining the thread. 'Couching' is

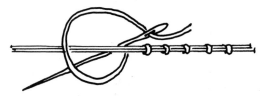

Cordonnet or foundation thread of Coton-à-broder No. 25 laid with sewing cotton. The threads must be held firm and taut while being couched down

laying the threads along the lines of the design, then sewing the laid threads down at right angles. Use a needle with fine thread and make the stitches at regular intervals, keeping them about 2 mm (⅛in.) apart. Pull the stitches secure but not tight, otherwise the laid thread will have a wavy appearance. Keep the two threads parallel while couching and do not allow them to pass over the top of each other. The threads must be held firm and taut while being couched down.

The prepared material with the design is now laid on the pillow and held in place by pinning all four corners. The material must hold secure while the work is in progress so pin along both sides if necessary.

WORKING METHODS

General hints

Make sure that the stitches remain the same size throughout the space being worked.

Take particular care when whipping along the edge of the space or down the cordonnet that the distance between the rows remains the same.

While working an area, the stitches are inclined to arch in the centre; they remain this way until the last row is worked. Once the stitches are caught to the base of the space, the lines will automatically pull straight as long as each row starts at the right depth.

Watch each loop as it is being formed, making sure the length of each loop corresponds with the previous one. In the same way, watch that the distances between stitches remain the same.

Do not try to watch the overall effect, just concentrate on the row in progress.

When working with fine thread, it is advisable to work a few practice rows on a sample to get into the rhythm of working the stitches.

Always work a filling from start to finish at one sitting to avoid any change in the tension.

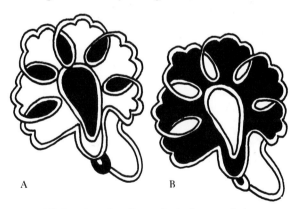

A B

A and B show how the effect varies in the same design when the Toilé is worked in different spaces

Petit Point de Venise

When worked singly this stitch can be used for the mesh as well as for fillings. Double stitches produce a dense filling and the treble stitches are useful when a large area has to be filled.

To work the stitch, join the working thread to the left-hand top corner of the cordonnet and make a buttonhole stitch.

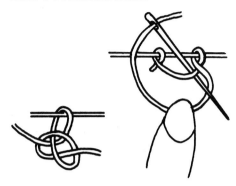

Lay the thread to the left as in the diagram, then place the needle behind the loop leading to the stitch and make a buttonhole stitch over the loop.

Continue to make the next stitch over the cordonnet, then throw the thread back to the left to make another buttonhole stitch over the loop between the two stitches on the cordonnet.

The return row is worked into the loops between the stitches; the working thread has to be thrown to the right to make the buttonhole stitch over the loop.

Venetian Point variation

There are examples of Point de Venise where the close buttonhole stitch is worked with a double knot. The second part of the movement is worked round the stitch itself and not back into the loop.

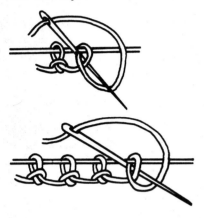

Work the first buttonhole stitch over the cordonnet; a second stitch is then formed round the first, taking the needle through at an angle. This forms a knot at the base of the first stitch.

Continue across the space, reversing the stitches to work back in the opposite direction.

For a heavy filling the loops can be either whipped or corded.

Point de Venise

The double stitch starts with two buttonhole stitches worked close together over the cordonnet, the working thread being thrown back to work one stitch over the loop between the pairs of stitches.

To give a longer stitch, after working the two stitches over the cordonnet, throw the thread back and work two stitches over the loop.

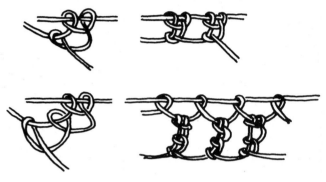

The treble stitch can be worked with either one or two buttonhole stitches made over the cordonnet, but they must be worked loose and all kept at an equal length. The thread is thrown back but, instead of working into the loop, three stitches are worked over the buttonhole stitch or stitches starting from the bottom and working up the stitch ending close to the cordonnet. Make the next stitch or stitches over the cordonnet, keeping them the same length as the previous ones.

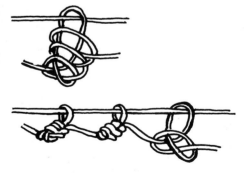

A large centre piece, worked by Dorothy McComb of New Zealand, who was instrumental in the writing of this book

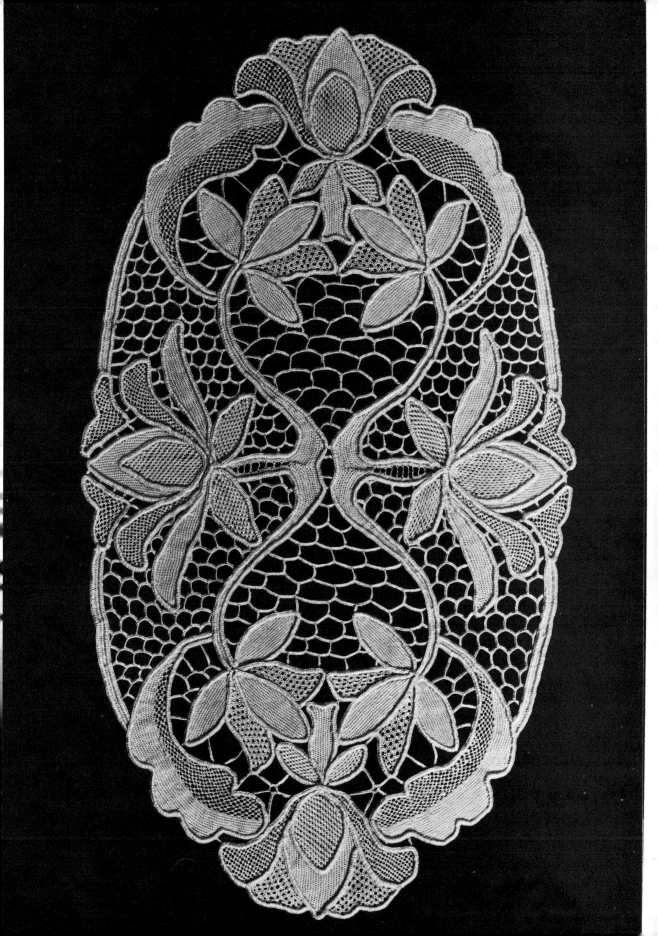

Belle Point de Venise

Commence at the right-hand corner of a space.

1 Work the first buttonhole stitch, then leave a space equal to the width of four buttonhole stitches and work another stitch. Continue across the space.

2 Work four buttonhole stitches into each long loop.

3 Work a buttonhole stitch between each stitch in the blocks of four stitches, giving three stitches and a long loop.

4 Work a buttonhole stitch between each stitch in the blocks of three, making blocks of two stitches. Throw the thread to the left, as in Point de Venise, and make a stitch into the long loop. Into the loop made, work seven or eight buttonhole stitches, forming a scallop or bell.

Make the next pair of stitches in the next block of three and continue to make a Point de Venise stitch as before. The number of buttonhole stitches needed to fill the Point de Venise stitch varies with the size of the stitch made. Each scallop or bell must have the same number of stitches worked into it once the number is determined.

Venetian doodle

I decided to see what would happen when a doodle was used instead of a formal pattern for lace. I wanted a 38 cm (15 in.) circle with a number of squiggly lines criss-crossing about to form the pattern, to have a medium textured lace on the outside of the circle with a more solid lace next to it. From there I would fill in the three or four other lace fillings, leaving some small areas completely unworked.

I drew out a circle on some heavy brown wrapping paper, cutting two pieces of cloth the same size as the paper to put under as the foundation. With the sewing machine set to a smallish zigzag stitch, suitable for couching over the tracing thread, I changed the pressure foot to one that had a hole in the front of it through which 40 crochet cotton was threaded and proceeded to machine stitch the tracing around the outline of the circle. The thread was not cut at any time but the pressure foot was lifted and moved to the next spot, finishing off with another tracing 13 mm ($\frac{1}{2}$ in.) from the first outline all round the circle, to be the finished edge.

I moved into the circle and commenced to machine the tracing thread over the whole of the inner circle, making squiggles and criss-crosses until a kind of crazy pattern emerged and the spaces were small enough to become little sections in which the lace stitches would be made. There was no need to keep lifting the pressure foot when turning; a good grip of the foundation enabled it to be swivelled as required.

All the lace in the circle was worked first, using 40 or 60 crochet cottons for nearly all but the very open lace, for which I used 150 crochet cotton. The Venetian Cloth stitch around the shapes was worked before the fillings with 60 cotton, leaving one edge unworked so as to accommodate the lace filling in the next space. This can become a bit of a brain teaser, trying to work out which edge to work before the fillings.

Soft embroidery thread was used for the cordonnet around the edge of the circle with 60 cotton for the buttonhole stitches. The inner row was done first using the soft embroidery for

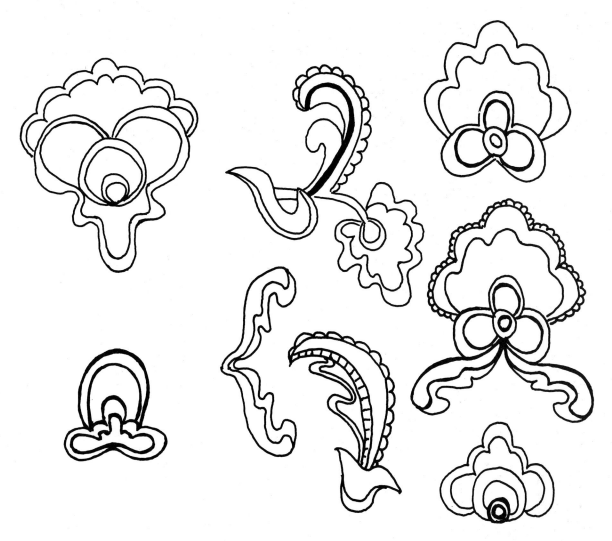

the cordonnet and, on the outside row, a bar was made every 13 mm ($\frac{1}{2}$ in.) to give a finish to the lace.

Opening the two pieces of cloth and snipping the couching threads was done very carefully. When the lace was off the foundation, a pair of tweezers was used to remove any threads from the couching.

I hope you enjoy making this piece as much as I did.

Contributed by Dorothy McComb of New Zealand

Typical Venetian Point motifs around the mid-seventeenth century. The larger motifs would have been joined together with smaller ones. Brides would have been used to strengthen any weak parts in the design but would not have formed any part of it

Dorothy McComb gives her own account of the progression of this modern piece of lace which she calls 'The Doodle' (page 78)

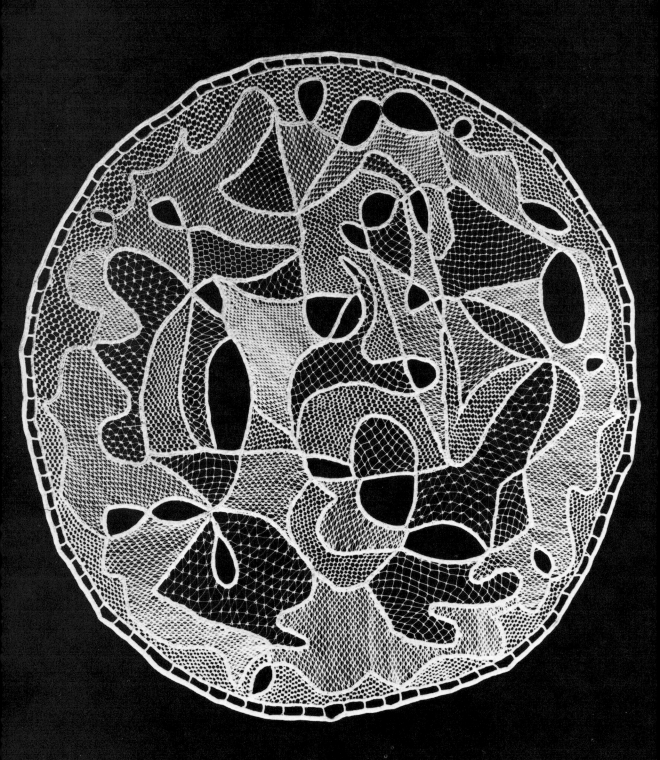

Spanish Point
Sometimes referred to as Point d'Espagne

Used singly, this stitch is found worked as bars for joining sections of lace together in early specimens of Spanish Point. Used this way the work is called Spanish Columns.

When used as a filling the stitch can be worked in various ways. It can be used as close button-holing for stems, trails, leaves and any other solid part of the design. When spaced evenly across the work, it can be either corded or whipped back over the loops. Any of the variations given for Point de Bruxelles can be used, ie working in pairs or trebles and leaving the equivalent space between the groups of stitches. The sequence of the Pea Filling and its variation can also be used.

As the finished stitch is almost twice the length of Point de Bruxelles stitch, the filling grows fast, but the space being filled should not be too small.

It is possible to work the stitch from right to left or from left to right. When working from the right join the working thread to the cordonnet a little way down the right-hand side of the space.

Take the thread up and under the cordonnet at the top, then twist the loop formed over the needle twice before pulling the needle through to form the stitch.

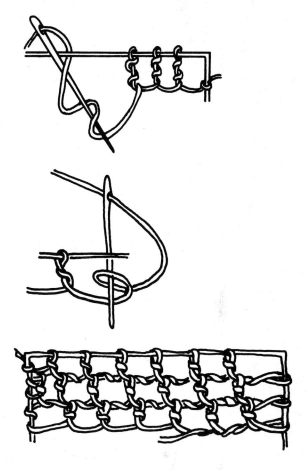

Point de Sorrento

Work over the cordonnet a buttonhole stitch, then take the thread back over the cordonnet and bring the needle through the loop of the buttonhole stitch. For the next and the following rows the stitch is worked over the loop of the previous row.

The effect of the stitch is lost if worked too tight.

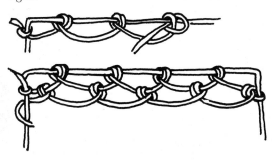

Sans Sols lace from South America. Each motif forming the inside ring is worked from the threads of the large central motif. These in turn work the diamond shapes.
The outside ring is made up of individual motifs attached separately (opposite)

Spanish lace
Tenerife lace wheel

Trace the circle of dots on to tracing paper and pin the tracing paper to a piece of glazed cotton. With a needle threaded with a contrasting coloured thread, stab stitch in and out of each dot until all fifty-two dots are worked, making sure that the needle enters and emerges exactly on each dot. Tear away the tracing paper and ink in each spot where the thread goes in or comes out of the material. Place the pattern on the pillow and insert strong stainless pins into the dots. Make sure there are fifty-two dots before continuing further.

Leave the heads of the pins standing about a quarter of an inch from the pillow. To commence, place the beginning of the thread round one of the pins and fasten the end to a safety pin attached to the pillow outside the ring where it cannot interfere with the work.

Take the ball of thread in one hand and pass the thread round the twenty-seventh pin. Working clockwise round the circle, take the thread back across the pillow to the pin on the right of the first pin, passing round each pin from left to right. Once the thread is round each pin, the pin can be pushed down to the head.

When all the pins are covered, draw off a long length of thread from the ball, cut off, and thread up with a tapestry needle or bodkin. Pass the needle under all the centre threads to the opposite side to make firm before starting to darn.

Darn three times round the centre of the circle, over or under each thread, drawing the first row tight. Continue to darn for three more rows.

To work the first circle of knotting, take four threads to each knot, make a backstitch but pass the needle under the working thread before pulling tight to form a knot.

Work twenty-six sets of four threads. Take the needle through the centre of the first backstitch to finish off the row.

Move out to the second row of knotting, still working with four threads, but start the second row with two threads from the first set of four and two threads from the second block of four. This will form a cross.

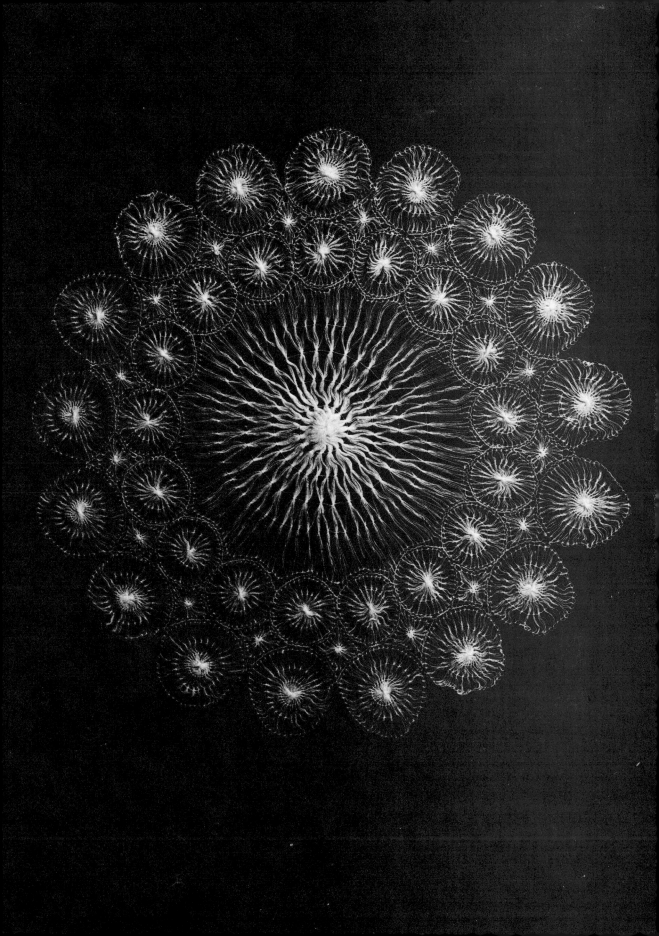

Continue in this way until the second row is worked, taking the needle through the backstitch of the first block on this row as for the previous row.

The third row is worked close to the pinheads. Take two threads, one from each pin, and knot tightly. Finish off by taking the thread through three or four backstitches.

The spokes of the wheels can be worked in any combination of numbers of threads using needleweaving and buttonholing as well as the knotting given in the working instructions.

Alençon mesh
Whipped stitch

Begin by making a row of spaced stitches over the cordonnet, taking the thread under and over the edge of the space or under and over the side cordonnet.

Whip over the loop of each stitch on the return row. As this is inclined to pull the stitches of the previous row out of alignment, pull the whipping into position after each stitch. Do not try to pull straight at the end of each row as this pulls the verticals to one side.

Take the working thread over and under the edge and, on the return row, make one stitch over each loop of the buttonhole stitch of the previous row.

The starting point will depend on whether the worker is left or right-handed.

A tighter effect can be achieved by working the second row of buttonhole stitches over both the loop of the previous row and the whipped thread; whip back as before. Continue to work over both base threads in each buttonhole row.

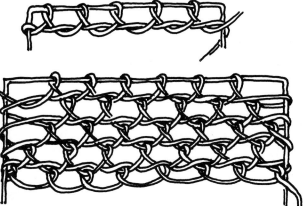

Réseau for Argentan Point
Bride d'Epingle

The réseau is formed of small hexagons worked over in buttonhole stitch. As the supporting stitches need to be evenly spaced, it is advisable to work from a pattern. Lay the tracing paper over a sheet of graph paper when marking out, to ensure the lines are straight. Then transfer the tracing to the fabric foundation.

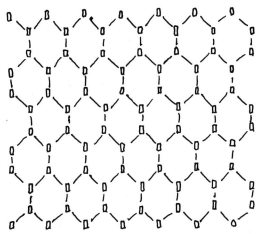

1 Using strong sewing cotton, place the upright stitches in each corner of the hexagons. These are only the holding stitches and will be removed on completion of the lace.

2 Leave a short length of thread at the beginning to fold back to the second supporting stitch. This will be worked over with buttonhole stitch to hold secure and will eliminate knotting.

3 The foundation thread is laid in the following manner. Take the thread through the first supporting stitch, top right; then down to the second stitch, taking the thread through from right to left; through the third supporting stitch from left to right making the vertical side of the first hexagon.

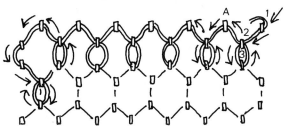

4 Take the thread back up to the second supporting stitch and through the stitch from right to left.

5 The thread is then taken through the second stitch on the top line marked A.

6 The thread will form the verticals of the second side of the hexagon; proceed in same way as before.

7 Continue across the three rows of supporting stitches until reaching the last hexagon. Instead of taking the thread back through the top stitch of the last vertical, the thread is taken down to the bottom of the hexagon.

8 On the return row, the thread must be taken through the *loops* formed by the verticals as well as through the supporting stitches. Unless this is done, the foundation thread is not connected to the first row, and is liable to fall apart once the supporting stitches are removed.

For true Argentan réseau, this procedure is repeated twice, working in fine threads.

Working the buttonhole stitches
1 Work along the top right-hand bar to second stitch, take the working thread down to the third stitch, then work in buttonhole stitch up the vertical. Take the needle through the loop of the last buttonhole stitch of the first bar before continuing.

2 Work the next two top bars and repeat for the second vertical.

3 For the return row, work down the last vertical then work one bar of the base of the hexagon; work the verticals as before, but down the right-hand side and up on the left.

4 Take the needle through the loop of the first buttonhole stitch of every vertical on each return row.

5 Cut the supporting stitches between the layers of material and lift. This foundation pattern is also the basis of Medici stitch, when instead of buttonholing the threads of the mesh, cording is used instead.

Ardenza Point

Join the working thread to the left hand vertical cordonnet at the depth of the intended stitches.

Make an ordinary buttonhole stitch on the top cordonnet, then throw the thread in a loop up and over to the right.

Take the needle and place under the cordonnet from below, over the working thread loop and pull gently downwards.

This makes a double buttonhole stitch. Leave a space, equal to the width of the two stitches, between each pair.

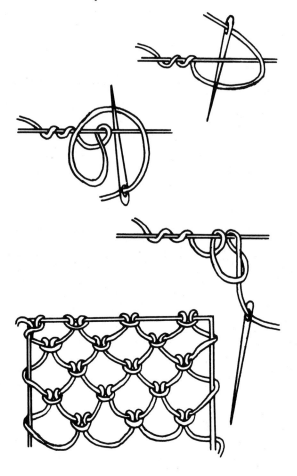

A pair of cuffs, nineteenth-century, worked in Ardenza Point with surface stitching on the muslin

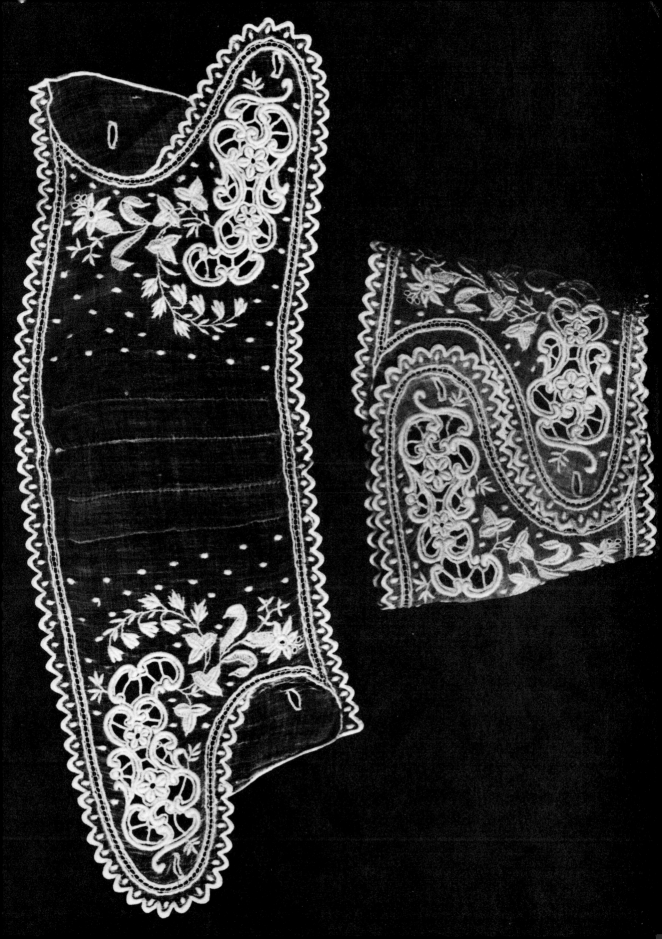

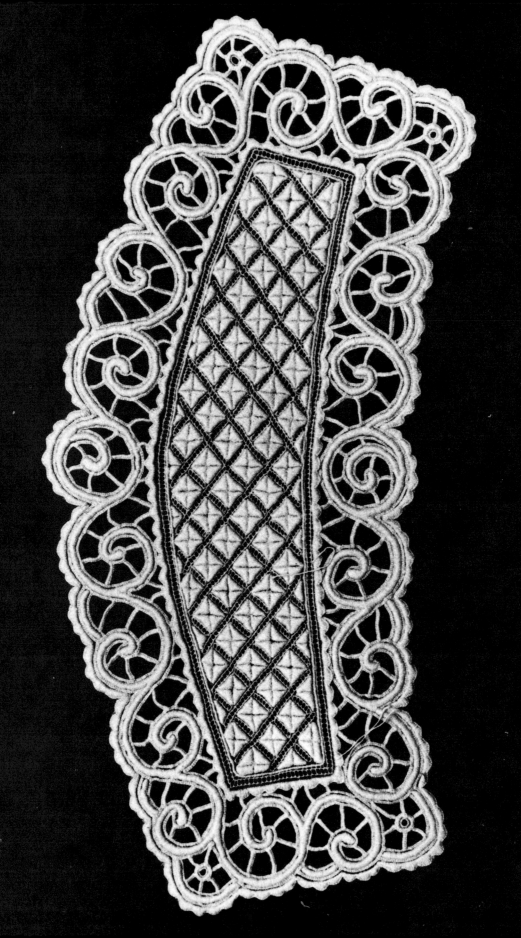

One of a pair of cuffs worked by the author in imitation of the first pair. The main part of the cuffs was worked on linen lawn on the cross of the material to form the diamonds. The stitch used was cushion stitch, usually found in canvas work. The scrolled edge was worked over a laid cordonnet with buttonhole edging worked into the outside edge of the Ardenza Point (detail shown below)

Continue across the space then, on the return row, each pair of stitches is placed on the loop of the previous row. This time the working thread is taken up and over to the left.

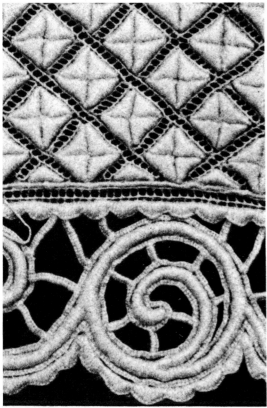

Ardenza Point bar

Join the thread to the cordonnet and whip into position for the first bar. Make the thread secure by oversewing twice, then take the thread across the space being filled and back.

Make a small buttonhole stitch into the cordonnet before working across the laid threads. Work a row of Ardenza Point across the laid threads.

Again work a small buttonhole stitch into the cordonnet on the other side before turning the work round. Now work a second set of Ardenza Point over the laid threads, and between the first row of stitches.

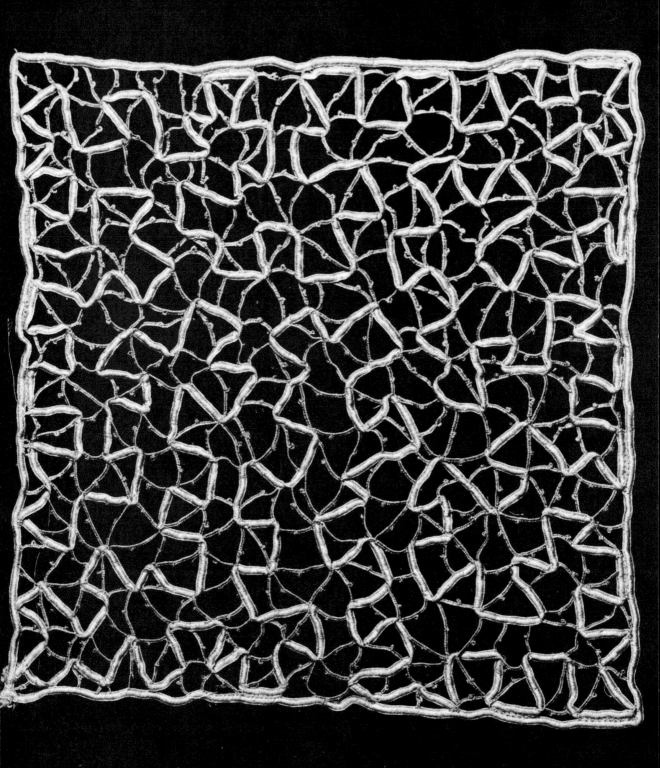

Lattice filling

Start the first row by bringing the thread out
from one side, three or four mm ($\frac{1}{8}$ in.) down,
take the thread to the top and make three close
buttonhole stiches. Make a loop long enough to
reach the depth of the starting point then make
three more stitches into the cordonnet at the
top. Make the spaces between the blocks of
three stitches equal their length; continue to the
end of row, then whip the working thread three
or four times down the edge of the motif being
filled, to equal the depth of the loops.

On the return row make three stitches into the
loops of the previous row; the working thread is
pulled tight between each set of three stitches.

Whip down the side to the correct depth, then
take the needle through the base of the three
stitches of the row above. Just whip, do not
make a buttonhole stitch. Leave a loop the
same depth as the first row and pass on to the
next three stitches. Continue to whip into the
base of each set of three stitches, leaving a long
loop, to the end of the row.

As in the second row, three stitches are worked
into the base of each loop, pulling the thread
tight as before.

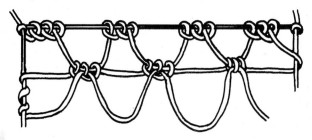

Ardenza Point place mat with
 bullion bars. The property of
 Dorothy Humphry

Brussels lace
Point de Bruxelles

Brussels mesh is worked with simple buttonhole
stitch. The height of the stitch must equal the
distance between each stitch. The first row is
worked over the cordonnet, then the working
thread is whipped along the edge of the motif
to reach the position of the next row.

The second row is worked into the loops formed
by the first row, always keeping the stitches the
correct height, working backwards and forwards
over the area being filled.

Close buttonhole stitch is worked in the same
way except the stitches lie next to each other,
forming the Toile.

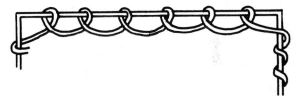

Point de Bruxelles is a spaced buttonhole stitch that forms
the mesh of the Brussels lace

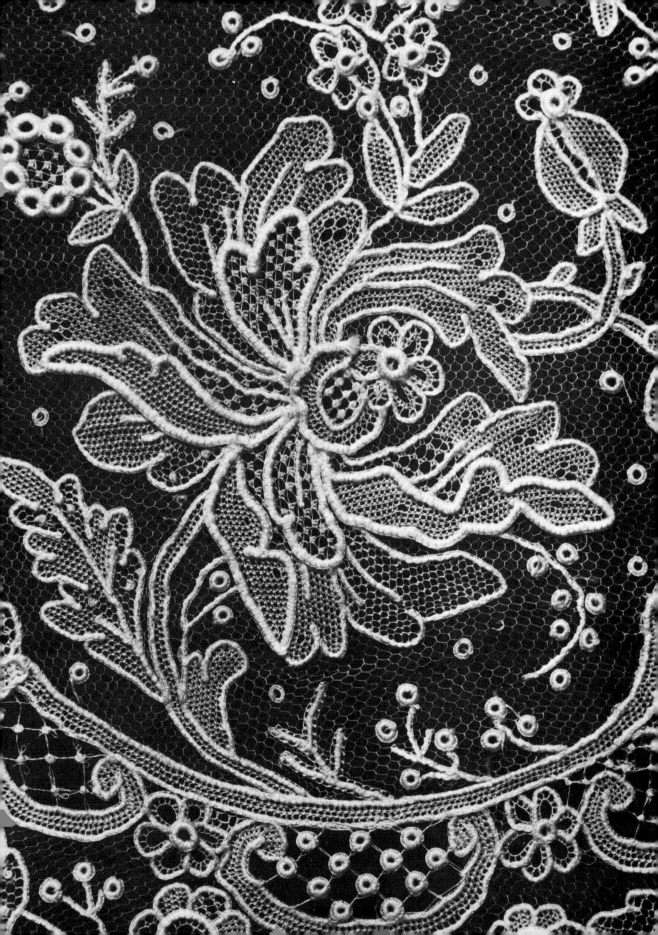

Variations
Double Brussels stitch

Make two buttonhole stitches close together over the cordonnet, then leave a space equal to the width of the two stitches before placing the next two stitches. Continue across the width of the area being filled.

Twist the working thread round the edge of the space to reach the depth of the second row. This is worked by placing one stitch into the first loop, then two close buttonhole stitches over each long loop of the previous row, placing one stitch into the last loop.

Take the working thread down to the third row. Start with two close buttonhole stitches placed over the loop of the previous row, directly below the stitches of the first row.

The loop between the pairs of stitches on the last row goes under and over the edge of the space or the cordonnet if being worked as a sample.

Double Brussels stitch forms a light filling

Treble Brussels stitch

Over the cordonnet work groups of three stitches leaving a loop between each group corresponding to the width of the three stitches. Continue in this way across the space to be filled.

Twist the working thread round the cordonnet and work the return row by placing a group of three stitches in the loops of the previous row. Leave a loop between each group of stitches for working the following row.

Treble Brussels stitch can be used to fill a large area. As with the double stitch the spacing must be kept even and the tension on the loops constant

The inner petals are worked in treble Brussels stitch.
The buds, outer petals and leaves have the corded filling.
The mesh is worked in Point de Bruxelles

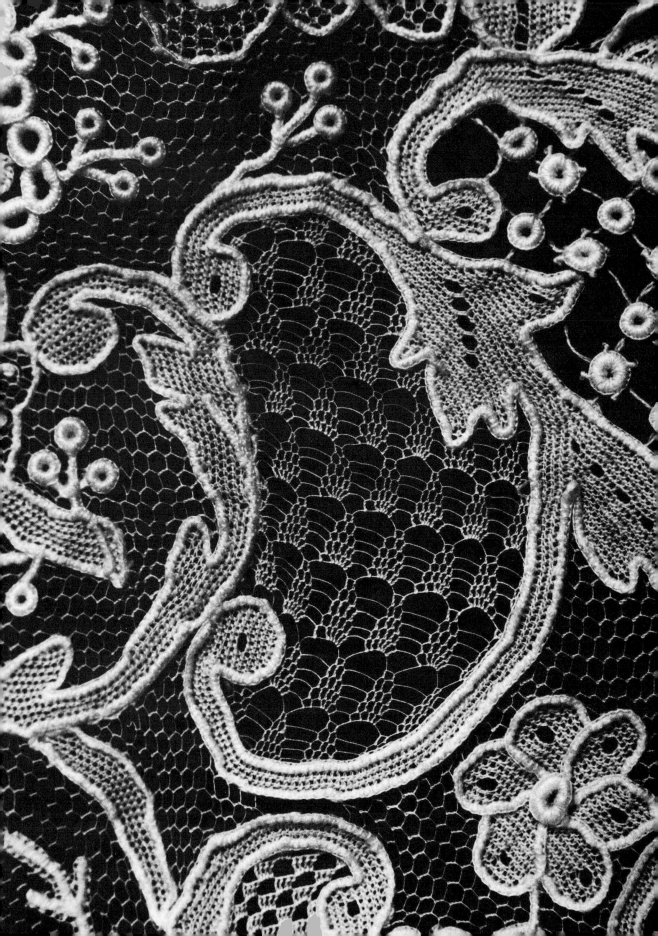

Inverted pyramid

This formation of stitches is found in lace other than that made in Brussels. All the stitches must be equal, while the tension on the loops is kept tight especially the last row where just one stitch is left holding a long loop. This loop holds the stitches for the start of the next set of pyramids and must be taut or all the stitches will sag instead of forming the straight top to the next part of the pattern.

Start with a row of close buttonhole stitches, the number of stitches needed for the top of each pyramid plus one space stitch between each set of stitches. If each pyramid is to consist of six stitches in width, then seven stitches must be worked across the space for each intended pyramid.

Work six stitches into the next six loops of the previous row, miss a loop and work the next six stitches into the next six loops. Continue to end of row.

Miss the loop and work the first stitch of this row between the first two stitches of the pyramid. Work another four stitches into the next four loops, make a long loop and work the next stitch between the first two stitches of the next pyramid.

Each row now starts between the first two stitches of the previous row. There is one stitch less in each pyramid and the loop gets correspondingly longer.

The second block of pyramids is formed by working six stitches into the loops of the last row of the first block.

Corded filling

A row of close buttonhole stitches is worked along the cordonnet; at the end of the row the working thread is taken under and over the edge of the motif and taken back on the same level as the bottom of the loops, then taken under and over the opposite edge.

On the next row the needle is placed behind the loop of the stitch above, behind the stretched thread, and formed into a buttonhole stitch. The needle passes behind two threads each time.

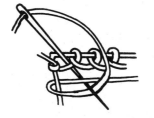

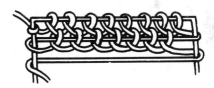

Inverted pyramids worked in Point de Bruxelles stitch making an openwork filling within a casket of corded buttonhole stitch

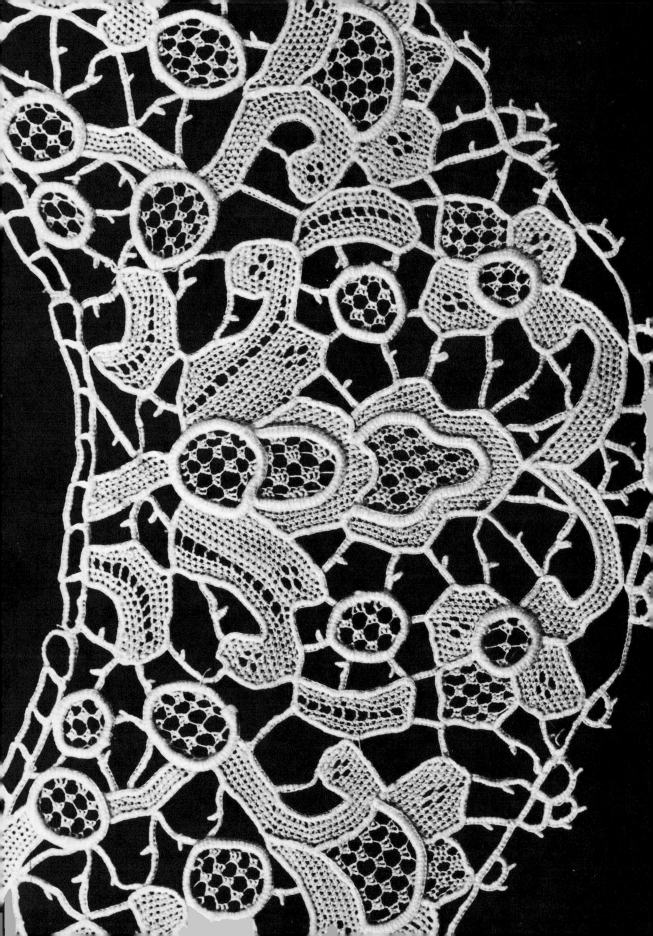

Pea filling

Work pairs of buttonhole stitches evenly spaced, the space corresponding to the width of each pair of stitches.

2nd row Work single stitches into each space of the previous row.

3rd row Two stitches are worked into each loop.

The second and third rows make the pattern.

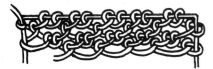

Pea stitch variation

Place a row of stitches along the top cordonnet at equal distances.

2nd row Make one buttonhole stitch into the last loop of the first row, then one buttonhole stitch into the next loop; miss two loops and make a stitch in each of the next two loops. Continue across to the edge of the space. Take the working thread under and over the cordonnet.

3rd row Make one stitch over the loop between the last two stitches of the previous row. Work three stitches over the long loop, work one stitch over the loop between the two stitches and work three stitches into the next long loop. Continue across the space, take the working thread over and under the cordonnet at the side for the return row.

4th row Make a long loop to reach the block of three stitches and make a stitch between each stitch (two buttonhole stitches); make a long loop to reach the next block of three and make a stitch between each (two stitches). Take the working thread over and under the cordonnet. Continue to work the third and fourth rows.

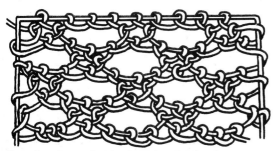

Part of a collar worked by the author showing the pea stitch variation in the lowest petal of the central motif. The

Filling an oval space

1 Lay the cordonnet round the outer edge of the oval and join the working thread at A.

2 Work two rows of spaced buttonhole stitch.

3 Whip the base of each loop, keeping the filling flat.

4 Work over the whipped loops for one row.

5 Whip the base of each loop as in the third row.

6 Repeat rows 4 and 3 as many times as needed to fill the space.

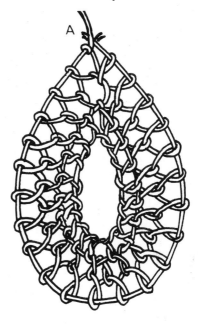

ring stick has been used to form the raised rings that surround the circles

Point de Grecque bar

This bar is useful for filling oval spaces or for centres of leaves.

Knot the working thread to the cordonnet at the top of the space. Then take the thread straight down to the bottom of the space. Take the thread over and under the cordonnet.

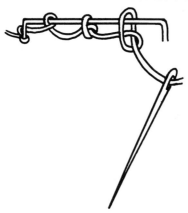

Now take the thread up and out to the position of the first bar on the left, this time going under and over the cordonnet.

Take the working thread to the right of the centre thread and out through the loop formed up and over to the left. Bring the needle under the loop lying over the cordonnet, under the centre thread and out through the loop formed by the working thread. Pull up to form a knot.

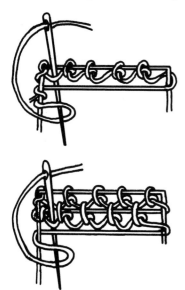

Take the working thread out to the cordonnet on the right of the space to the position on the second bar. Pass the needle under and over the cordonnet and back through the centre knot. Pull up to bring the knot central.

Continue up the space, placing the bars at regular intervals. Finish off by taking the working thread through the knot at the top and tie off.

Venetian picots

The Venetian Picot is the longest in length and perhaps the most awkward to work, so it will be the first to be dealt with. Work the buttonholing of the bar from right to left. At the spot where the picot is to be worked, place a pin either under the foundation threads of the bar and into the base material or, if working on a pillow, stick the pin straight through into the pillow itself.

The needle is then taken round the pin to the length of thread required for the picot. Make a buttonhole stitch over the bar, taking the thread under the pin a second time from right to left.

Throw the thread in a loop over the top of the bar and to the right-hand side of the picot.

The thread is then taken over the right-hand side of the first loop, under the working thread, over the pin, under the left-hand side of the loop and over the working thread.

Pull the thread tight forming the end of the picot, buttonhole up the remainder of the loop to the bar. Then continue to buttonhole the foundation threads of the bar to the position of the next picot. The number of buttonhole stitches between picots must remain the same and, in the same way, the picots must be composed of the same number of stitches.

Loop picot

This is the picot used to adorn the A'jours and Couronnes. It is also worked from right to left.

Work along to the position of the first picot and insert the pin as for Venetian Picot. Pass the working thread from right to left under the pin, then still working to the left, over the top of and down behind the bar or foundation threads.

Throw the working thread over the point of the pin to the right.

Make a buttonhole stitch round the picot by taking the working thread under both sides of the loop but over the pin, under the working thread where it emerges from behind the bar, then over the working thread where it is forming the large loop.

Pull tight to form the picot. The spacing of these picots will depend entirely on how and where the picots are being used (even the length of the picots can be varied) to form scallops.

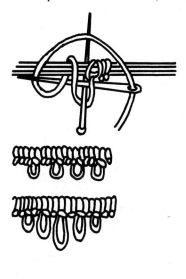

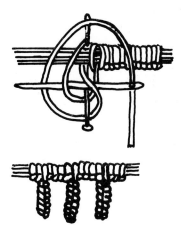

Venetian picots worked with woven bars to form a filling for a wheel in a piece of Point de Gaze (page 98)

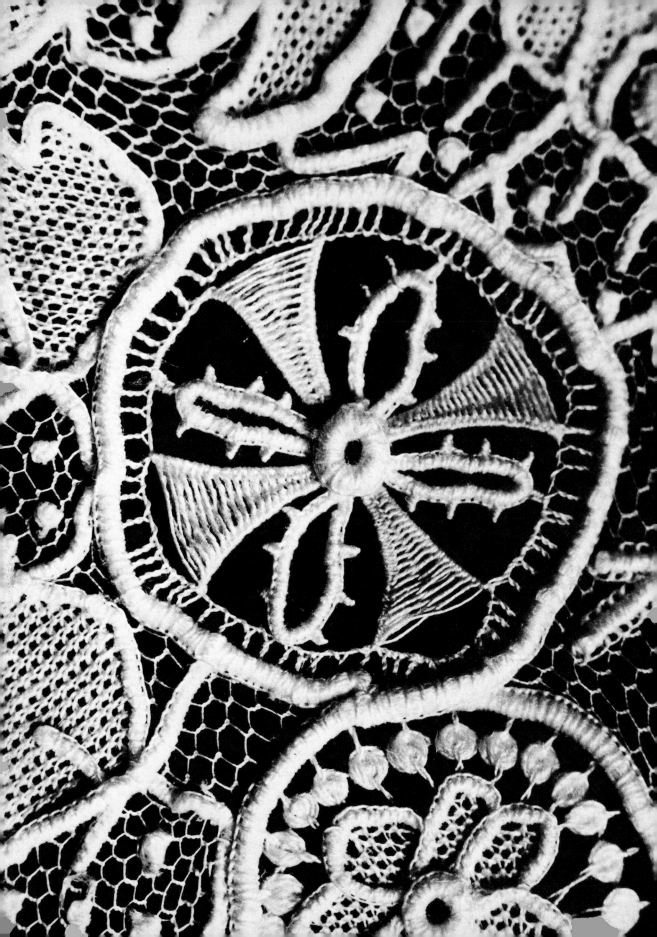

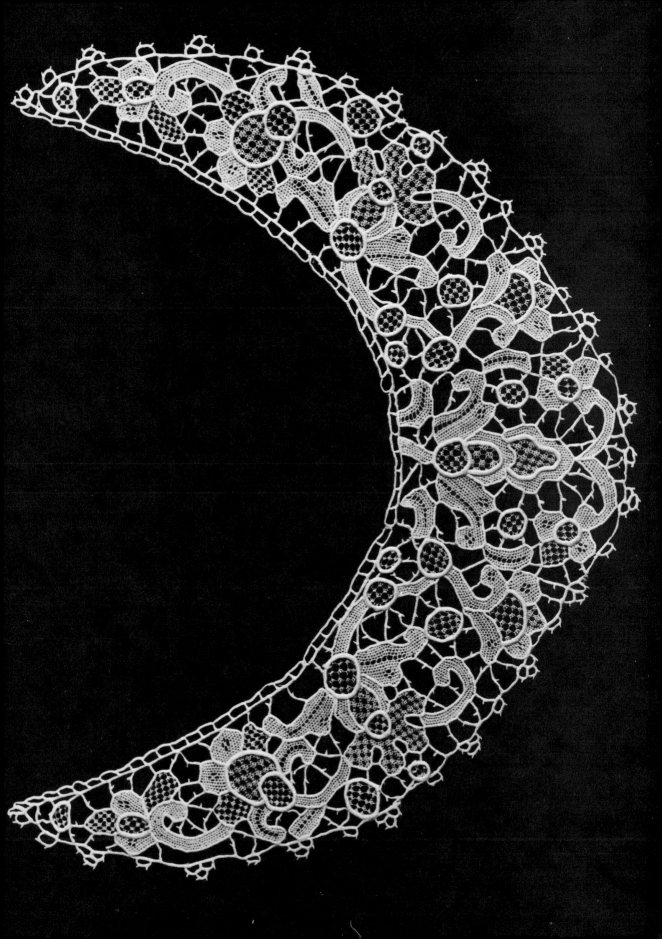

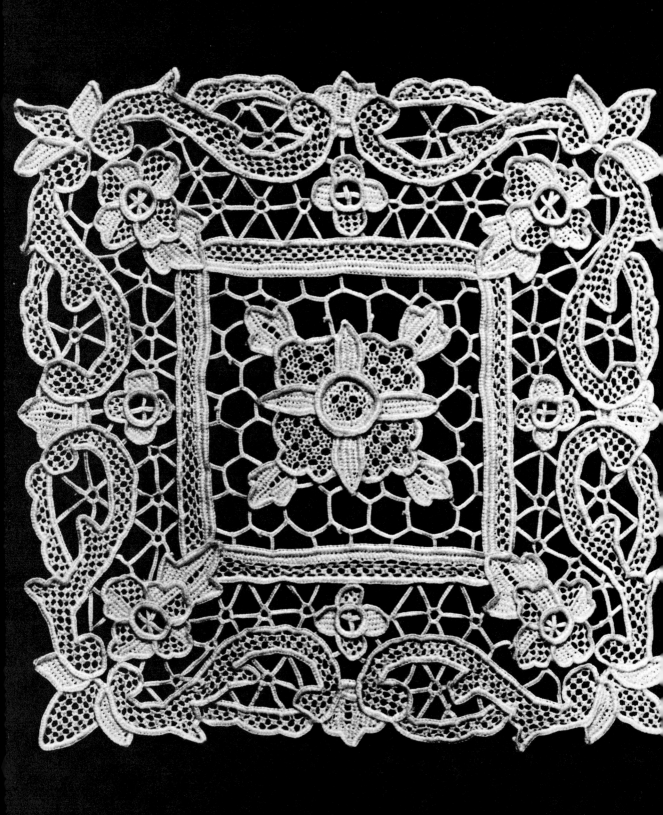

Bullion bars

This is a small tight picot. Sometimes every bar in a piece of lace has the same number of picots spaced evenly across them. Branching bars are often found with two picots placed one each side of the centre of every bar.

Work from left to right along the bar to the position of the first picot. Place the needle back into the down bar of the last buttonhole stitch.

Twist the thread six times round the point of the needle. The thumb is then placed over the twists while the needle is pulled through.

Tighten up the thread to draw the twists into a curve. This is kept in place by working the next buttonhole stitch against the previous one.

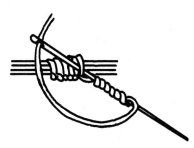

Purls

Work one row of buttonhole stitches for the foundation row. To work the purl, make a buttonhole stitch leaving a loop the length of the purl, throw the working thread to the right then down and round to the left.

Place the needle behind the buttonhole stitch and through the loop formed by the working thread; pull tight to form a knot.

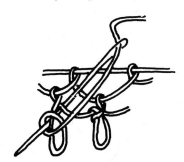

A collar worked by the author using many of the stitches given in the chapter on working methods (page 99)

A small modern mat from Cyprus, using only stitches found in this book. A clear example of branching bars which have been used for the ground. The property of Kit Pyman

Russian bars

Work alternately from top to bottom of the space being filled. The top twists are placed central to the lower twists, and the distance between each stitch must be kept equal.

Join the working thread to the cordonnet half way between top and bottom of the space being filled.

Take the thread down to the bottom (the needle is always taken under and over the cordonnet) then whip half way up the working thread.

Take the needle under and over the top cordonnet and whip down the working thread, keeping the same number of twists as were placed on the bottom bar.

Continue in this way until reaching the end of the space.

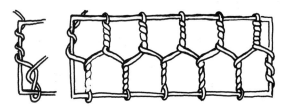

Alençon beads

Work two opposite rows of buttonhole stitches along each side of the space to be filled.

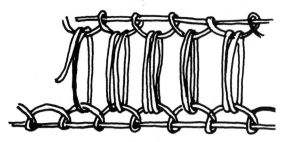

The working thread is passed over and down through the top loop, then the needle enters the bottom loop from behind; now make three more loops into the same space.

The threads of the stitches must lie beside each other and not be allowed to pass over each other.

After the fourth loop, twist the working thread round the bottom buttonhole stitch and carry it through to the next, to make the four loops of the next stitch.

When the row is worked, run the back of the thumb nail down each block of four loops to make them lie flat.

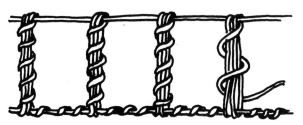

Alençon bars

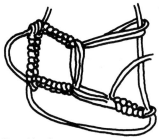

Branching bars

Hollie point or holy stitch

1 Lay the cordonnet round the design and attach the working thread to the right-hand top corner.

2 Take the working thread across to the left, laying it close to the cordonnet, then under and over the cordonnet on the left-hand side.

3 The stitch is made by placing the thumb over the working thread, which is then wound round the thumb from right to left.

4 The needle is inserted behind the cordonnet, under the transverse thread and through the loop laying over the thumb. Pull through to form the knot.

5 Continue across to the right side then take the thread over and under the cordonnet (or vice versa).

6 Take the thread back to the left, laying it close to the loops of the first row of stitches, then under and over the cordonnet.

7 For the second row of stitches the needle is placed under the loop of the stitch above, then passed under the transverse thread and through the loop round the thumb.

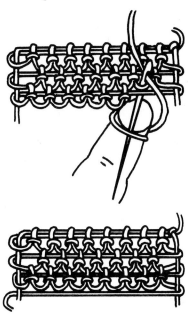

Wheel ground No 1

Join the working thread to the cordonnet and lay the first of the foundation threads 6 mm ($\frac{1}{4}$ in.) apart along the length of the design.

Place the second layer of threads the same width apart across the design making a background of squares.

Another set of threads is laid diagonally across the middle of each square from right to left.

Then another set is laid diagonally from left to right.

At each intersection where all the threads cross make a woven wheel, by placing the needle under two threads and taking the thread back over one thread. Work three rounds in this way.

As each wheel is finished, twist along one of the threads to the next intersection.

Another way this filling can be worked is to lay the threads as before, making a series of squares, then bringing just one set of diagonal threads from left to right, through the centre of each square.

Make a woven wheel at the first intersection, then twist along one thread to the next. Instead of working another wheel, knot all threads together with a buttonhole stitch. Then twist along a thread to the next intersection and make another wheel.

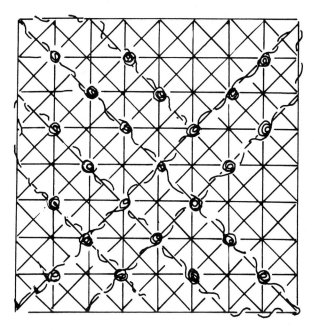

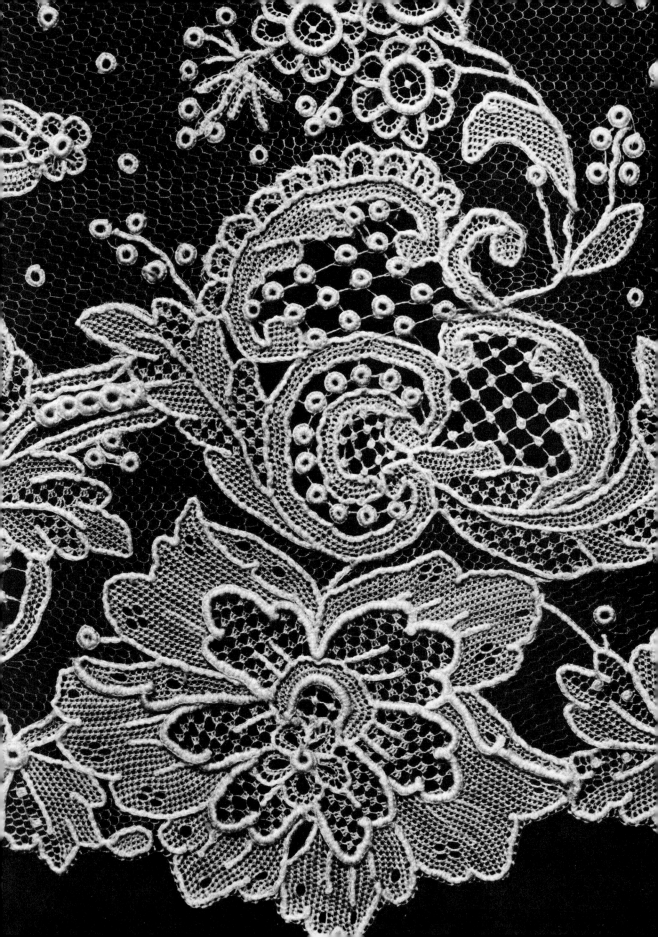

Point d'Angleterre
wheel filling No 2

Laying the foundation thread for this filling is much quicker than for the previous wheel fillings. Lay the cordonnet and attach the working thread to the top *right*-hand corner.

Double rows of working thread are laid diagonally in one direction over the area to be worked. Lay one line of working thread at right angles over the first foundation threads. Twist twice round the cordonnet then return the working thread to the first intersection.

Take the needle under the first pair of foundation threads, over the single thread just laid then under the double foundation threads on the opposite side of the single thread.

Now continue to weave *over* the next threads lying at the top of the wheel being worked and under the first pair of foundation threads worked. This finishes off the first wheel.

The working thread is now taken over the single thread and under the next two foundation threads and another wheel is woven in the opposite direction.

Alternate the weaving of the wheels, first anti-clockwise then clockwise down the pairs of foundation threads. Take the needle under the cordonnet at the base of the area being filled, twist under and over the cordonnet until reaching the next pair of foundation threads. Turn the work round, if possible, and work down the second row of double threads in the same way.

If it is not possible to turn the work round, the second row of wheels have to be worked up the second row of foundation threads.

Each wheel should be lying in the opposite direction to its neighbour. Continue until the area is filled, decreasing or increasing as necessary. Sometimes an odd wheel is needed to fill an awkward corner or curve; make sure this is worked in the right direction to the main body of the filling.

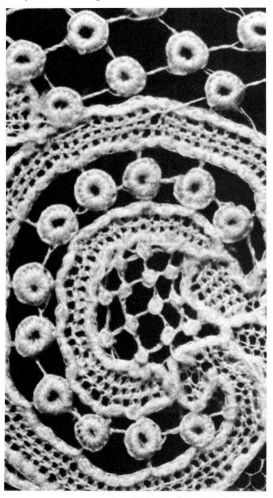

Wheel Filling Point d'Angleterre along with another variation of buttonhole rings worked over the same type of foundation (detail right)

105

Filet stitch

Double knot or net stitch are other names given to this mesh, which is worked diagonally in both directions. It is an imitation of the following netting but instead of using the shuttle and mesh stick, this stitch is worked with a needle. This is the method that was used for both Italian and Cluny Filet.

For the Italian or Richelieu Filet the designs were needlerun, with an outline of thicker thread. This type of lace was made in Sardinia in large quantities and was the forerunner of Coggeshall and Limerick laces. The Cluny Filet has designs of flowers, leaves and figures worked in the darning technique.

The following instructions and diagrams explain the method of working the mesh, while designs and fillings can be found under Limerick lace.

1 Couch the foundation thread round the area to be filled. Then take the working thread and fasten with a half hitch knot to one side of the work.

2 Twist the working thread round the foundation thread two or three times to get in position for the height of the mesh. The height must equal the width of the mesh and must remain the same througout. Figure 1.

3 Take the working thread and make a buttonhole stitch over the top of the foundation thread as in figure 1 at A.

4 Twist the working thread twice along the top to reach the position of the next loop. Figure 1 at B.

5 Pin the loops in position as this will keep the loops a uniform size.

6 Insert the needle behind the loop from the front to make a buttonhole stitch as in figure 2.

7 Lay the working thread in a clockwise movement to the left as shown.

8 Insert the needle behind the buttonhole stitch, bring the point of the needle over the thread leading off the loop, then take the point of the needle under the thread lying to the left.

9 The completed stitch is shown in figure 3.

10 Instead of working diagonally back up the work, it is sometimes found easier to turn the work round to work the row down again.

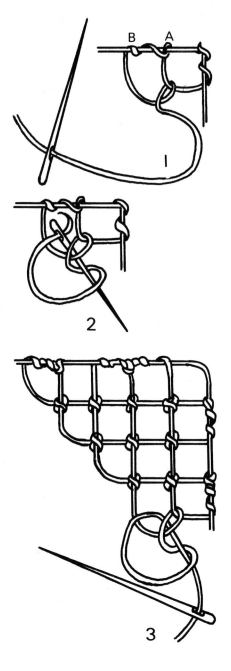

Netting, using filet stitch and the heavy filling given for Limerick lace (detail shown on page 108)

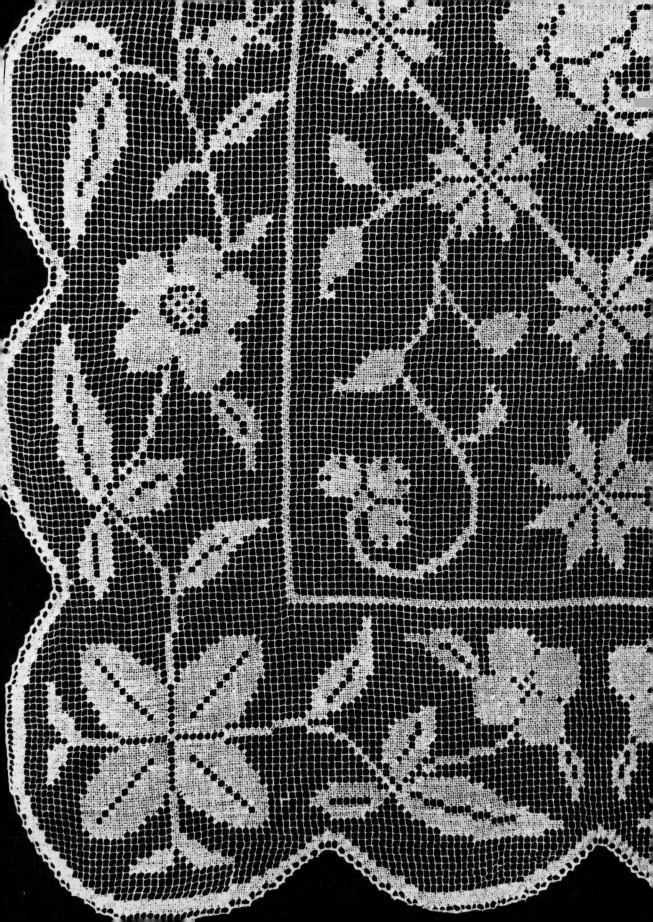

Netting

The lace mentioned in the Old Testament is a knotted lace, it is the net used for Guipure d'Art and Filet Brodé à Reprises, which are names given to darned netting. Knotting was practised during the Middle Ages and goes back so far in time that its origin is lost.

A weight is needed to hold the work and can be made from a house brick and a large wooden curtain ring. On one side of the brick there is a recess; place this uppermost. The curtain ring is then tied to the brick, the knot forming over the recess in the brick (figure 1). Do make sure that the knot is secure. Pad the brick all round with layers of wadding or cotton wool and cover with material. Sew neatly all round then make a slit in the top and pull the curtain ring through. Neaten off the slit (figure 2).

Tools needed for making the net are a shuttle and mesh, which can be obtained in different sizes. Until the turn of this century netting tools could be bought in sets, often in beautifully carved or inlaid boxes made of ivory, bone or polished wood. The meshes start at about 3 mm ($\frac{1}{8}$ in.) and go up in sizes in much the same way as knitting needles do.

The netting shuttle needs to be about 125 mm (5 in.) long; the points at both ends must be smooth and slim to allow ease of working (figure 3).

A long loop is tied to the curtain ring, called a stirrup, because at one time ladies worked with the loop under the instep of the foot. It is easier to work from a weight at table height.

All netting is worked from left to right. Two rows have to be worked to form the diamond shape net. The number of diamonds are counted, not the number of rows worked.

When the shuttle is empty, refill and join the new thread with a knot, always joining at the beginning of a row.

To make a square of netting, begin by making two stitches into the stirrup. Slip the stitches off the mesh and turn the work. Proceed as for plain netting but increase a stitch at the end of every row by working two knots over the last loop of the previous row. Increase to the number of stitches required, remembering that an extra stitch is needed to the number of holes required along one side of the square. Work one

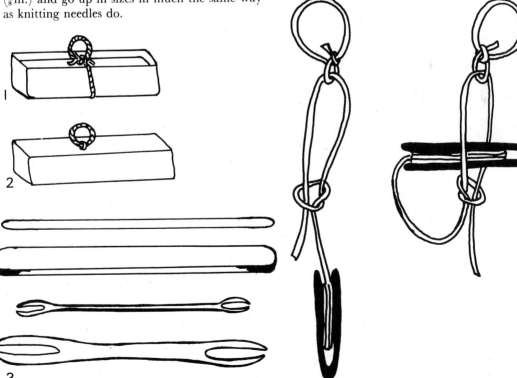

row without increasing. Work the other half of the square by taking two loops together at the end of every row until just two stitches remain.

To work a circle of net the easiest way to start is to form a grommet. Do this by tying the working thread of the stirrup with a separate length of string. Work the stitches into the loop formed with the grommet not into the loop from the stirrup. Follow the illustration for making the overhand knot to form a grommet.

When the right number of loops are placed put the tail through the end of the grommet loop and draw up to form a ring. The work is continued in the round.

To work the Fisherman's knot

1 Bring the needle or shuttle over and under the mesh, up behind the work and through the stirrup.

2 Draw the shuttle through in the direction of the left shoulder.

3 Pull the thread tight round the mesh and hold it with the thumb.

4 Take the shuttle behind the stirrup from right to left, through the loop leading from the thumb.

5 Draw the thread tight and repeat for the number of loops needed to complete the first row.

6 Turn the work, making the last loop on the right of the first row into the first loop for the second row.

7 Bring the thread over and under the mesh and insert the shuttle from the back of the work through the first loop on the left and continue as for the first row, taking each loop in sequence.

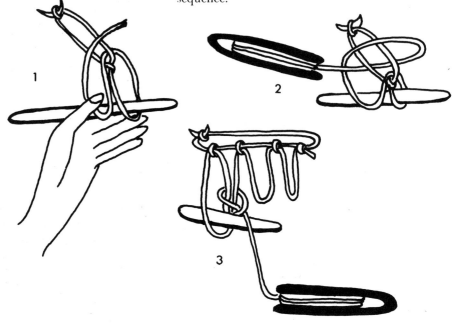

Working details for a hammock

A hammock would need a piece of netting
2.5 m (2¼ yd) long by 1.25 m (1¾ yd) wide. Use
a coarse string or a macramé twine. The mesh
would need to be made 50 mm × 10 mm
(2 in. × ⅜ in.) to produce the right size net.

When the necessary length of net has been
made, slip one end on to a thick piece of wood.
Thread a length of rope through the loops of
the other three sides of the net and tie or splice
both ends of this rope to the bar of wood.

To hang the hammock, a length of rope is
attached to the wood at one end and, at the
other, another length picks up the corner loops
as well as the rope edging the hammock.

Carrickmacross lace

The main points to remember are: use a good
quality muslin (cotton if possible), good work-
manship and the right net. Unless the muslin is
pre-shrunk, problems will arise when cleaning.

Materials – close-woven muslin, washed and
pressed while damp, a special net (see list of
suppliers). Crochet cotton, either No. 60 whip-
ped with No. 150, or No. 80 whipped with
Alsace 30 for fine work.

Needles – should be the finest crewel available; a
coarse needle will leave holes in the muslin.

A design – traced on glazed cambric or drawn on
paper then covered with a film of acetate.
Choose green or blue film to avoid eye strain.

Scissors – special scissors are available with an
excrescence on one point. This allows the
muslin to be lifted from the net while being cut
away after the design is applied.

Method of working
Appliqué
Lay the net over the prepared cambric, making
sure there is sufficient net to extend well beyond
the design.

Carefully tack the net to the cambric, making
sure it is neither stretched, pulled on the cross
nor puckered. Lay a piece of muslin, large
enough to extend well beyond the design. Start
from the centre and tack out to one side. Do
not knot the thread when starting; this will
allow the needle to be unthreaded at the out-
side edge, re-threaded at the centre to work out

Part of a large flounce of Carrickmacross using the finest
muslin which tends to throw the couched thread into high
relief. The couched thread round the base of the flounce is
twisted on itself to make the picots, while every so often it is
reversed to make a picot onto the muslin (pages 112, 113)

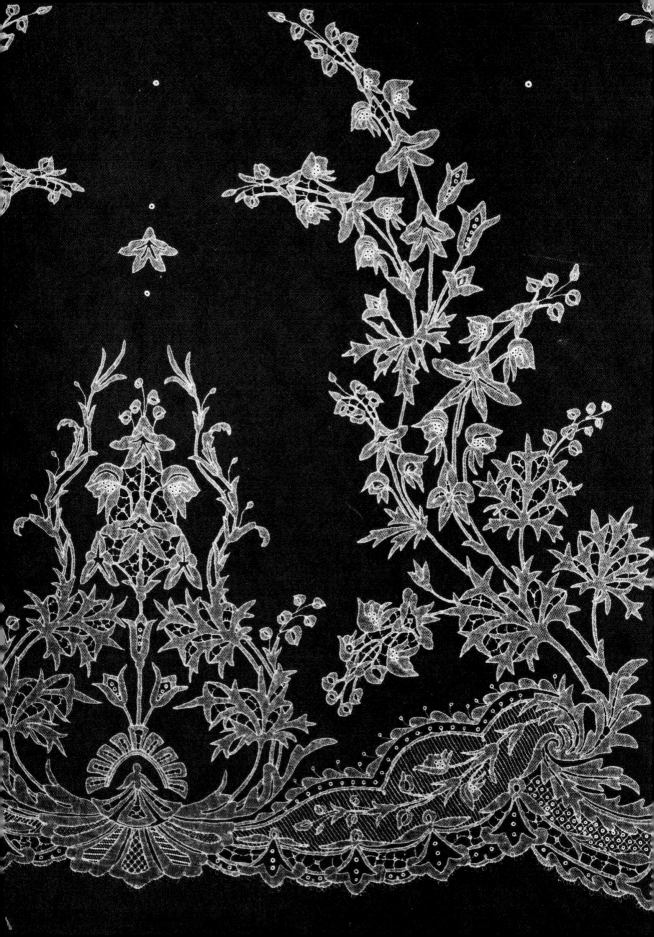

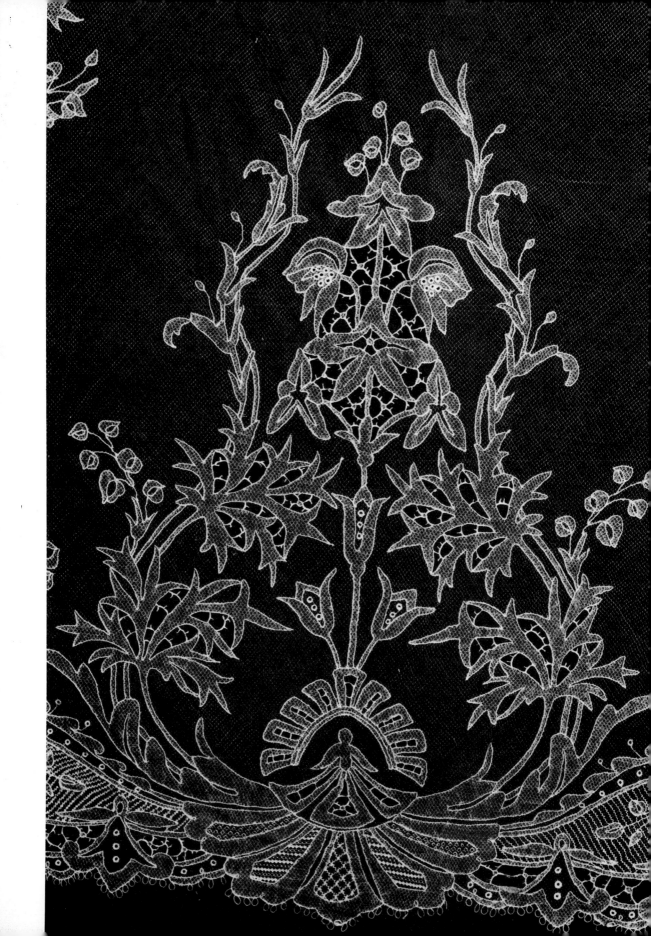

to the other side. Do the same from the centre to the top of the design, then from the centre to the bottom. Tack all round the outside of the design; neither the net nor the muslin must shift on the foundation while working. Use the finest cotton for all the tacking and avoid tacking through the muslin that forms the design; this would leave holes which are difficult to remove. The stitches should be very neat and closely worked, making sure that the net and the muslin are caught up with each stitch. Keep the cording true to the designs; sharp corners need an extra stitch to keep the bend from curving.

When the cording is finished, the surplus muslin is cut away close to the cording on the outside of the design. The stitches used for the fillings are the same as those for Limerick and Filet.

Guipure

For practice, use a medium weight lawn; it is more substantial than muslin. Then tack to the cambric in the same way as for appliqué.

The cording is done in the same way but without the net base. The grounding is composed of buttonhole bars, with picots, d'Alençon bars, twisted Russian stitch, with the addition of fillings for caskets or centres of flowers, etc. All the ground work is done before removing from the foundation cambric. Once the lace is removed it is turned upside down and the muslin is then cut away from the 'pattern'.

Working the Angel

For laying the cordonnet, try to visualise the parts of the design that appear farthest away, as this has to be laid first; for the angel it will be the halo.

Take great care to catch the net and the muslin with each stitch but on no account catch up any of the threads from the cambric foundation, if not using the PVC film.

Run the working thread through the cordonnet for about 10 mm ($\frac{3}{8}$in.) in the opposite direction to the way the stitching is to be worked and oversew the end of the cordonnet three times to make it secure at point A.

Continue to whip stitch the cordonnet at intervals of 1 mm ($\frac{1}{16}$in.) to the net and muslin until point B is reached. Oversew three times to secure the cordonnet to C and continue to whip

back to D. Continue to lay the cordonnet in the following manner – start at the top of the forehead, work down the face, neck and front of dress until reaching the arm. Take the cordonnet along the top of the arm, marked E, then fold back and whip along the arm to the hand. Whip along the cuff and back down the arm to F. Fold the cordonnet back on itself and whip to the start of the gown at G. Whip down to H, then up to I. Make the cordonnet secure then fold it over on itself and whip back to the hemline. Continue round each of the folds of the gown and round the bottom of the hemline, then up to J; whip three times and cut off.

Next lay the cordonnet for the wing and continue round the wing back up to the hairline. Work each feather in the wing next, overcasting firmly at the start and finish.

The hair is laid in from the tip of the curl at the base, taken up the back of the head, whipping over the thread already laid in at the wing, round the top of the head, down the forehead and back down, crossing in a figure-of-eight at the curl to finish by whipping over the start at least three times.

Where the cordonnets pass or cross whip together once or twice. Work the hand with fine thread in back stitches.

The shaded parts of the design are then cut away from the net. Even with the special scissors great care must be exercised when removing the muslin; it is advisable to do this once the embroidery is taken off the foundation cambric. Cut the muslin from around the outside of the design leaving the angel in relief against the net background.

Limerick lace

The design

When designing for Limerick lace try to keep a fluid line with not too many isolated motifs. Both back and front of the work has to be neat and tidy, which means that the fastening off of all threads demands care and attention. It follows that the fewer ends there are to fasten off the better.

Centres of flowers or spaces between the design were always called the casket area. These caskets were filled with various fancy stitches, many of them were the drawn fabric stitches used in the Irish Guipure of that period. Any drawn fabric stitches will look effective but the choice of not more than two will stop the design from becoming indistinct and confused. Never use more than one fancy stitch in any one casket, and always consider which will contrast best against areas of heavy or light fillings. A large pattern will look out of place in a small casket as there will not be enough room to work a sufficient number of repetitions to show the pattern properly.

Materials

Net is made up of holes, which is the 'mesh', and four threads surrounding each hole which are the 'bars'. Different angles of the mesh of the net will cause the same stitch to take on different characters. A long-pointed diamond mesh will make the same design look completely different than when worked on a mesh of square diamonds. The same applies when worked on a hexagonal mesh or a round-hole net.

Equipment

A round embroidery frame is necessary for working the outline. A floor stand for the frame or a table clamp leaves both hands free to manipulate the threads. This enables the worker to control the twists and knots that often form in the fine threads used for the fillings. A pair of sharp-pointed embroidery scissors is also needed. It is best to work this type of lace without a thimble, as the slightest snag puckers the work.

A Limerick lace stole, the property of The Royal School of Needlework. The great variety of fillings could fill another book. Much of the lace made at the turn of the century has a machine made picot edging. This type of edging was sold by the yard, along with a braid used for tape lace (page 116)

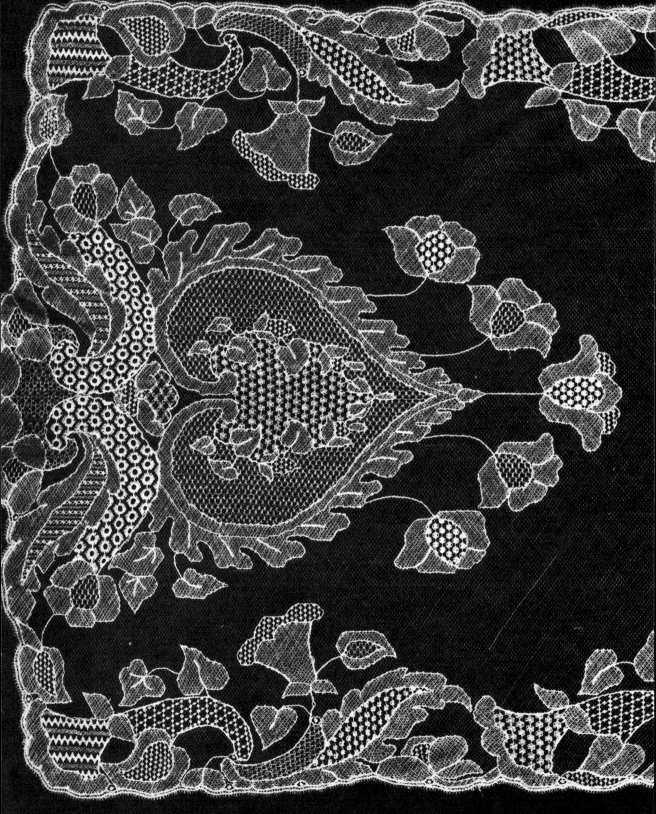

Threads

DMC Fil à dentelle is ideal for the outline of the design. This thread will impart a gloss finish which is a feature of this lace. The Alsace 60 thread can be used for the fillings; machine embroidery thread is also suitable or *Drima* T.

Detail from a beautiful cape of Limerick lace, worn at the wedding of Queen Victoria in 1840, now in the possession of The Royal School of Needlework (page 118)

Enlarged detail (page 119)

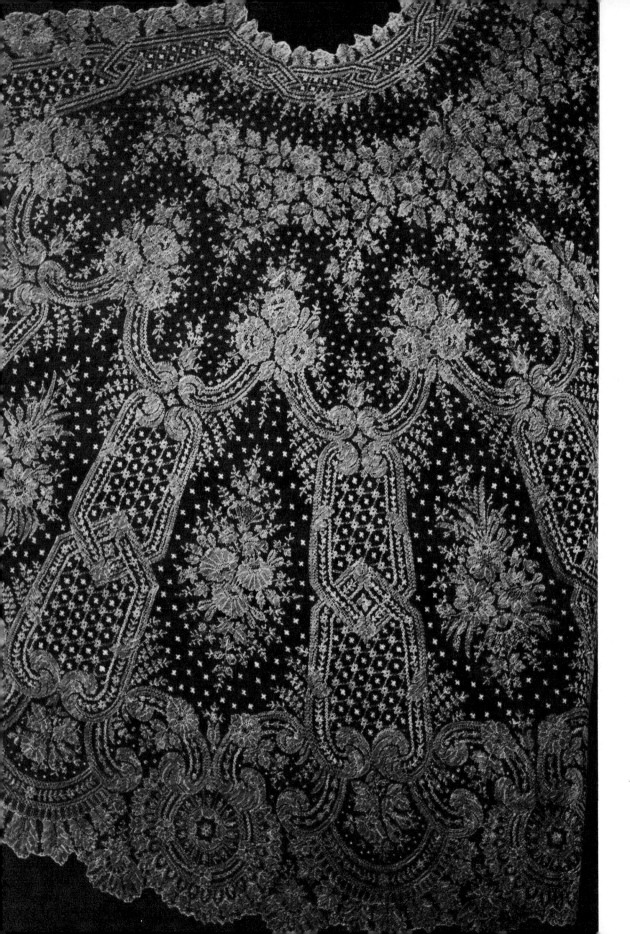

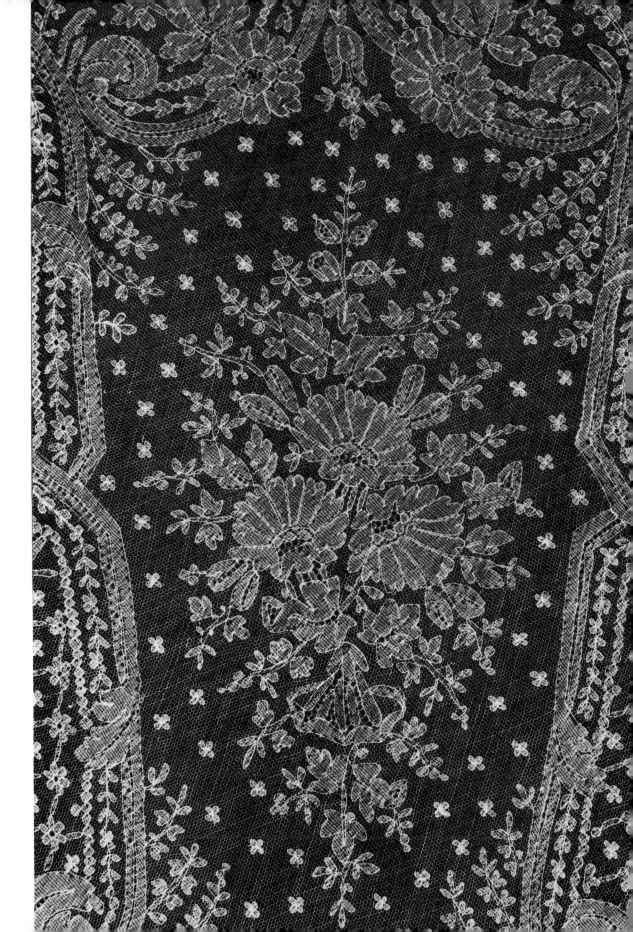

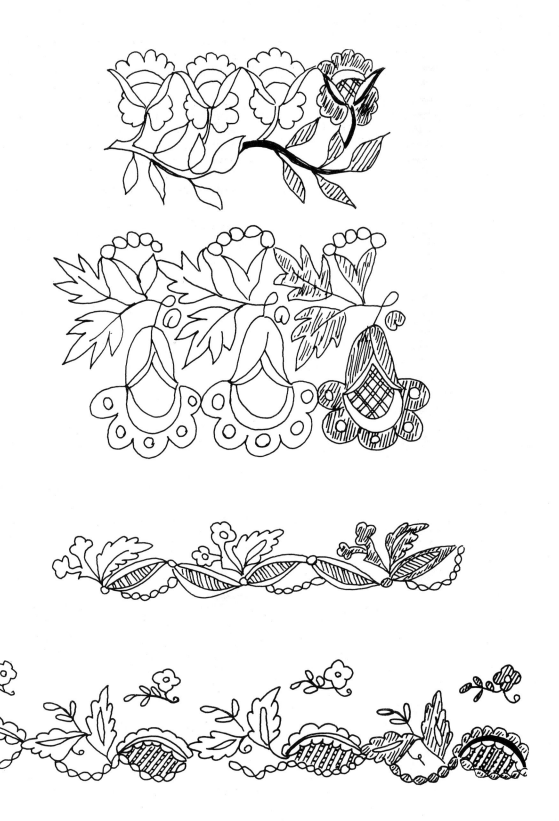

It is best to use a fine tapestry needle for the running in of the outline. For the filling stitches use a fine crewel needle.

Method

Select the design to be used, trace off on the greaseproof paper and transfer to cambric and mark in, following the instructions given for Carrickmacross lace.

Next tack the net to the design on the cambric. Make sure the tacking stitches are not in the path of the design or trouble will be encountered when removing the net from the cambric. Make sure also to keep a constant tension, the net must not be puckered nor must there be loops in the running stitch. The design is then put in by running stitches over and under each thread of the net using the thread double for the outline.

Keep as near to the outline as possible as it is easy to lose the flow of the design because net is an arbitrary material and absolutely refuses to hold a stitch that comes in the middle of a mesh. If the design takes on an angular appearance, make a bigger sweep than shown in the design, when laying in the outline. Often it is necessary to take the thread back over the same line to save cutting off and rejoining the thread. Avoid laying in two lines side by side; it is always better to return the thread by overcasting the first run. This also applies when passing from one filling to another. Instead of cutting the thread, overcast along the outline to reach the next point of work.

When the design is completely laid in, remove the net from the cambric. If by chance any tacking thread has been caught up, cut the tacking thread before and after the caught stitch and remove the piece of thread once the net is off the cambric. The design should stand out very distinctly from the net background.

Take two pieces of soft sheeting about 30 cm (12 in.) square; old handkerchiefs or old shirts are good for this purpose. Cut a 15 cm (6 in.) diameter hole in the middle of both pieces. Lay one of these pieces flat, place the net with the centre of the design in the middle of the hole, then lay the second piece of material over the top of both leaving the net showing through a round window.

Take the inside ring of the frame and place all three layers centrally over this, then push the outside ring down over the material. As each part of the design is finished, remove the material, re-centre the net to the next area of the design to be worked and place back into the frame. A green or blue cloth placed over the lap of the worker is of immense help to see the mesh clearly. If working over a table with the aid of a clamp, then the blue or green cloth should be laid over the table; never work in the position that allows the light to be seen directly through the net.

The work is now ready for the filling stitches. These stitches are always worked with the fine thread. When reaching the end of a row of any filling stitches, overcast along the outline to the next row. Always arrange a heavy filling next to a light one; the heavy fillings act as shading in the areas of the design where necessary. The thread is fine enough to allow the worker to start by laying the thread to a bar with a knot; choose a bar close to the outline and the knot will disappear into the cordonnet and the filling stitch will completely cover it. To finish off, run the filling thread through the cordonnet for about 12 mm ($\frac{1}{2}$ in.) before cutting off.

Just to recap before going on to the fillings: a mesh is a hole in the net, and a bar is one of the four threads surrounding a hole. The design is the pattern, a casket is an area enclosed within the design. Cut off all loose ends before starting the fillings to avoid any entanglements. Should the thread twist and knot, place the needle in the little loop that forms and give a gentle tug on the thread holding the work down with the tip of a little finger firmly over the last stitches made. If this is not done the work may be drawn up leaving a nasty puckering. If the knot fails to give, cut off and unpick back to the outline, then start again with a fresh thread.

The two fillings commonly used are heavy filling, which is darning, and light filling, which is worked in tent stitch.

Heavy filling

Knot the working thread to a bar on the outside of the design, bring the needle through a mesh on the outside of the outline. Pick up a bar, then miss one across the diagonal of the design. On reaching the last stitch of the line on

the opposite side of the design, take the needle through to the mesh directly outside the outline thread and bring it out one row further down. Make the second row of darning by picking up the missed bars and passing the worked bars of the previous row. Again take the needle through the mesh on the outside of the outline and bring the thread through one row further down the design. Continue darning until all the design area is filled. There is now a laid thread lying parallel with the bars.

These rows of laid threads and bars are now covered at right angles in the same way. Always pick up the bars and miss the laid threads. At the end of each row take the needle through one mesh beyond the outline and bring it back out, one mesh down, outside the outline, ready for the return row.

Light filling

This filling grows rapidly but it would not be a satisfactory finish if the whole lace was worked in this stitch alone, as it would look too flimsy. The filling is composed of tent stitches; commence at one side of a space, work across the rows taking a perpendicular stitch behind each place where four bars meet; insert the needle two bars up and one to the left, bring it out two bars down and one to the left; repeat for the length of the row; each row is worked on a bar lower down. The stitches can be worked horizontally or diagonally. Take care that the needle is inserted above the same bar as it came out of in the preceding row. Remember, in order to reach each row, to overcast the cordonnet outline of the design.

Limerick lace fillings

Fancy fillings

Many of the fancy fillings are made up of diagonal lines of tent stitches spaced at intervals with a second set of rows set at right angles to the first set of rows. When working horizontally hold the net so that the meshes appear to be diamond shape. Commence at one side of a space and work across a row taking a perpendicular stitch behind each place where four bars meet.

Fancy filling 1

This is composed of diagonal lines of tent stitch. The spacing of the rows will depend entirely on

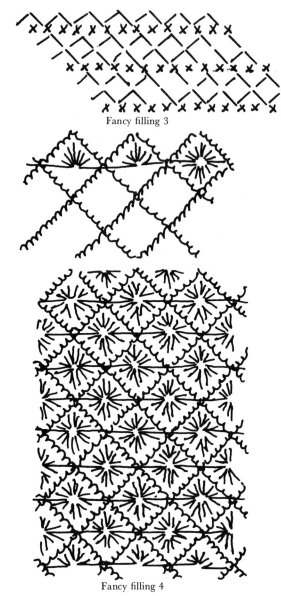

Fancy filling 3

Fancy filling 4

the size of the casket being filled. A small casket could be worked over alternate rows one way and eight spaces between rows, at right angles to the first rows.

Fancy filling 2

Space the diagonals to fit the casket and in the areas between the tent stitch lines work satin stitch spots. This can be worked in squares instead of oblong boxes by leaving spaces of three meshes and four bars between the rows each way.

Light filling

Fancy filling 3

When working the cross stitch filling, use a
single thread but work over each cross stitch
three times. Work the thread as unobtrusively
as possible from one space to the next. Work
over a four-mesh three-bar basis for the tent
stitch squares.

Fancy filling 4

By leaving an odd number of meshes and an
even number of bars between rows, a series of
eyelets can be worked in the centres of the
boxes, worked on the basis of five meshes and
four bars; three meshes and two bars would give
a dainty filling for a small casket. The filling is
worked in two halves; the top of the eyelet is
worked first crossing the working thread behind
the mesh where the two diagonal lines of tent
stitch meet, passing over to the second eyelet in
the next square. On reaching the edge of the
casket, take the working thread to the outside
bar over the cordonnet and back to the centre
of the last eyelet worked. Now repeat the half
pattern, making a whole eyelet into each square
of the diagonal lines.

Fancy filling 5

This filling is worked in cross stitch for the
diagonal lines instead of tent stitch. Space the
diagonals to fit the casket, working on the basis
of five meshes and four bars to each pattern
counting on the diagonal of the net. This can be
worked horizontally using the same count of
five meshes and four bars.

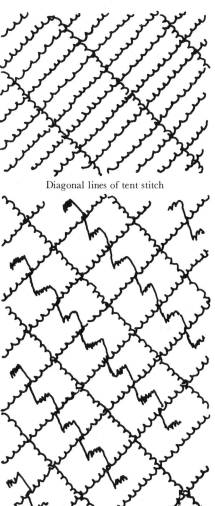

Diagonal lines of tent stitch

Filling stitches for Filet or Limerick

Single Point Serré

This is worked in the same way as Herringbone stitch, using the bars instead of a background material to form the stitches.

Join the working thread to a bar with a half hitch. Working from left to right, start on the row above the hitch. Place the needle behind and above the two bars at the next intersection. The needle is placed from right to left; bring the thread through and draw up; do not pull too tight.

Take the thread down to the row of bars where the hitch was made, miss the next intersection, place the needle behind and below the two bars of the next intersection from right to left and draw the thread through. The stitches are formed on alternative intersections.

Work across the area to be filled, then twist round the last bar to the depth of two meshes.

On the return row the needle is inserted from left to right, the thread being placed above the bottom point of the first row, and taken down to the next intersection. The needle is taken behind and below these bars and the thread drawn up. Continue across the row forming a single line of diamonds.

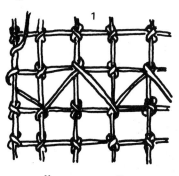

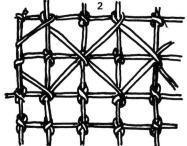

Point Serré Closed Diamond

Instead of working the diamonds in two separate rows of Herringbone stitch, this diamond starts in the centre of a four-mesh square.

Work from the left horizontal bar, down to the bottom bar, round to the right horizontal bar and on to the top bar, the needle being placed right to left on the bottom bar, top to bottom of the right horizontal, left to right over the top bar and bottom to top of the left horizontal. Work two or three times round the outside of the first line of threads before moving on to the second diamond.

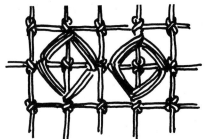

Point Serré Double Diamond

A buttonhole stitch is used in place of the Herringbone stitch for this version of Point Serré. It is worked over the outside of the bars of each four-mesh square.

Start with a half hitch over the left-hand bar, make a buttonhole stitch on each bar and work four rounds to form a diamond. Then work the next two bars to bring the working thread round to the right-hand side bar. At this point take the needle under the stitches made on this bar and bring the thread up on the inside of the diamond just made.

The thread is now taken over the top of the threads forming the first diamond and down to the bottom bar for the start of the next diamond. The following diamonds are worked in the same way, each one interlinked with its neighbour.

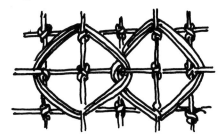

Point Croisé

This stitch is worked on two rows of Single Point Serré. Work a series of Point Serré from left to right over an even number of bars. On the return row, work a single buttonhole stitch where the two rows of Point Serré pass on the central bars of each four-mesh square. The serré stitch makes the legs of the wheels.

With the working thread, start at the bottom left-hand corner of the first four-mesh square. Twist twice up the first leg of the cross to the centre and work a wheel. Take the working thread under the first bar to the right, over and under the legs and bars as they come in the circle until reaching the twisted leg.

Take the thread under the twisted leg and make one more round. On reaching the twisted leg the second time, bring the thread up at the centre of the woven wheel. Now twist the working thread twice round the leg leading to the bottom right-hand corner of the square, making one complete Point Croisé.

Continue across the space being filled using each four-mesh square, then lay two rows of Point Serré for the next row of Point Croisé.

Point Tiellage

A quick stitch giving a figure of eight. Worked in two directions. Keep the net taut; this stitch is worked diagonally across the mesh and it is easier to see the 45° angle if the net is kept tight.

Start at one corner of the area to be filled, take the thread diagonally across to the other corner and twist round the bars so that the thread lies diagonally behind the next mesh. Continue in this way along the line, keeping rigidly to the 45° angle.

The return row is worked in the same way, reversing the throw of the thread, forming a cross in the middle of each square as the second thread follows the path of the first.

The first diagram shows the thread laid through the centre of the mesh to make it easier to follow. When working the stitch, it would be started in one corner as in the second diagram.

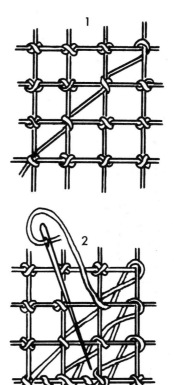

Point d'Esprit

Fasten the thread to the middle of a vertical bar and work a loose buttonhole stitch over each horizontal bar, and behind each vertical bar. The size of each loop must equal half the depth of the mesh. Always work from left to right.

At the end of each row, turn the work, so still working from left to right.

Make a stitch over the vertical bar to reach the horizontal above.

Continue in buttonhole stitch along the horizontal bar taking the thread behind the loop of the buttonhole stitch below, over the vertical bar, then back under the same loop to the right of the bar.

The thread is now in position to make the buttonhole stitch on the next horizontal bar to the right.

Woven bars

The bars can be worked over two, three or four laid threads and are basically darning, over one thread under one thread.

Woven bars can be used to fill large areas as in some Spanish lace or over just two threads when joining motifs in fine work.

Woven pyramids

These can be worked over the laid mesh given for Wheel filling No. 1 omitting the first row of vertical threads. Start at a point where two threads cross at the 45° angle over a horizontal thread. Weave over and under down two sides of a triangle until reaching the next horizontal thread.

Take the working thread under the next pair of crossed threads and under the horizontal, then weave down the triangle formed by the next set of crossed threads. These pyramids travel down the laid mesh at a 45° angle and can be worked to the right or left.

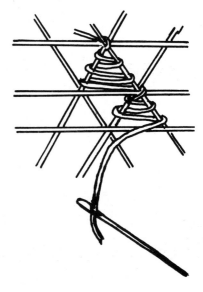

A design based on the first Telstar communications satellite launched in 1962, using needleweaving for the bars and leaves, and cording for the outlines and scalloped edge, with picots placed on each scallop. Worked by the author

The central filling is composed of individually made rings attached to a foundation of threads laid as for wheel filling 1. The centres of the scrolls and leaves are filled with corded buttonhole stitch (page 128)

The wheel filling is made up of Ardenza Point bars and woven triangles attached to a ring of Bruxelles stitch around the cordonnet (page 129)

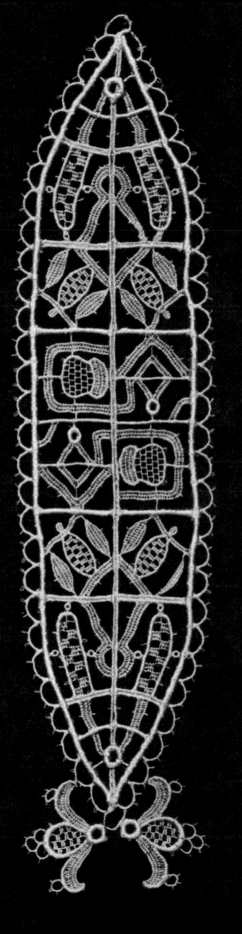

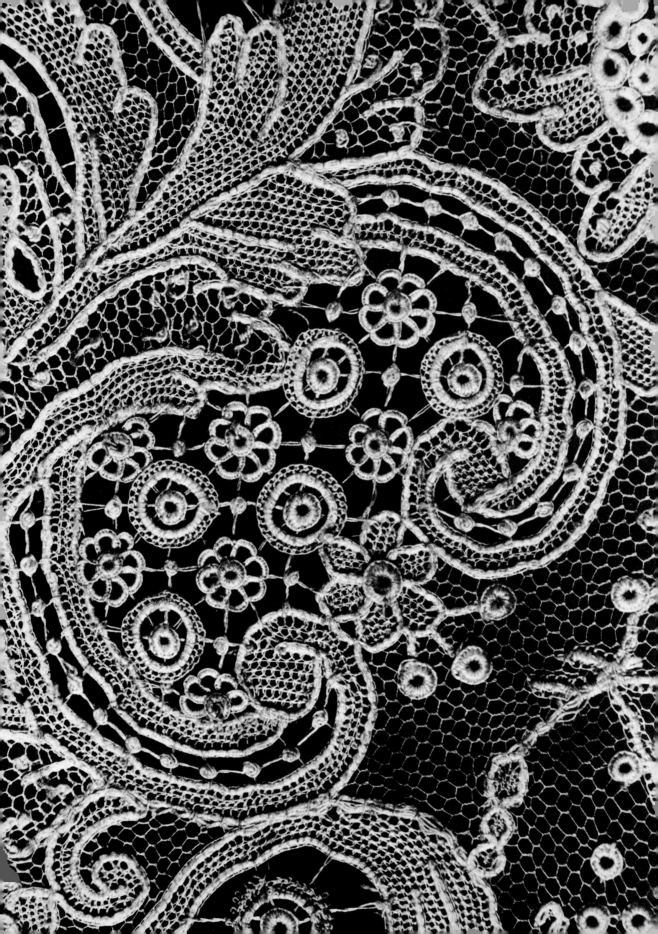

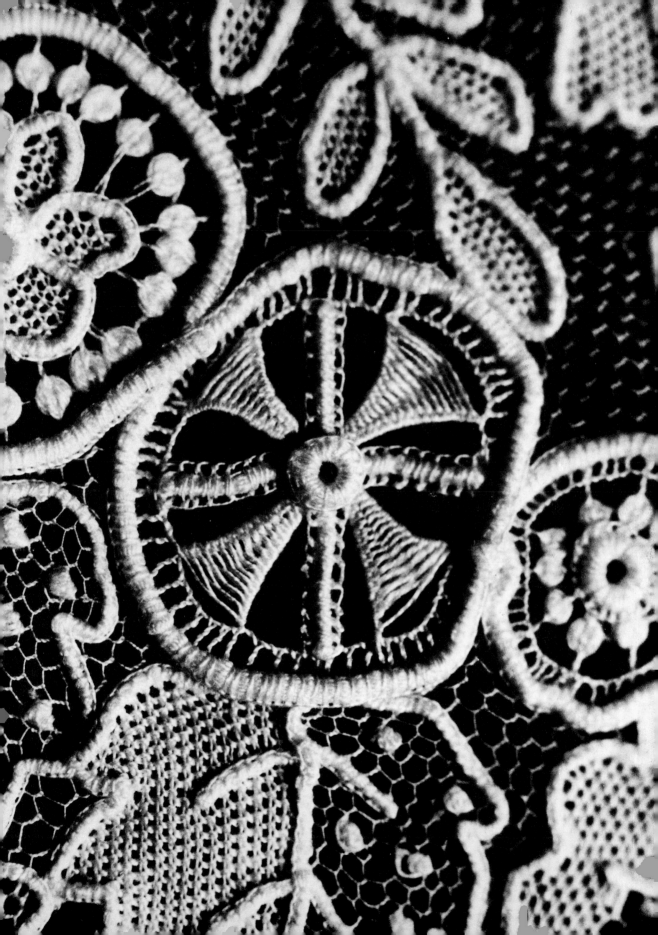

Wheel Garland

To fill a long narrow space, take the working thread from top to bottom of the space.

Lay a series of foundation stitches at right angles to the first thread from one side of the space to the other at regular intervals, working from bottom to top.

Secure the thread at the top of the space then whip down the laid thread to the intersection.

Weave under and over round the four laid threads forming the cross, which brings the working thread back to the top vertical thread.

Take the needle through the loop formed by the whipped stitch on the vertical.

Then take the needle under the right horizontal and over the bottom vertical.

The needle is now taken up behind the ring to come out of its centre and down over the threads forming the ring to whip down the vertical to the next set of crossed threads.

Continue in this way to the bottom of the space.

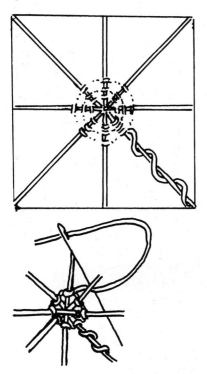

Russian filling

Lay a foundation of horizontal and vertical threads to cover the space to be filled.

Start at the top of the first left-hand vertical and whip, from right to left over the thread, to the first intersection.

Take the working thread at a 45° angle over the laid threads where they cross, then whip along the horizontal threads, under and over, out to the left-hand side.

Whip down the edge of the design, or space, to the next horizontal.

Take the working thread over and under this horizontal to where the threads cross, place another whip stitch at a 45° angle to take in the vertical.

Continue up to the intersection and lay a whip stitch, again at the 45° angle to lie beside the first. Then whip out along the horizontal, make the 45° angle whip stitch yet again to continue up the vertical to the top. This will have worked two parallel rows in steps from top to side and back to the top.

The filling continues to be worked in this way until the last of the top verticals; from then on, it is worked from the right-hand side down to the bottom and then back up to the right again.

Buttonhole rings

These are made to size over a ring stick and then sewn into position. They are used as centres of flowers or sewn onto a mesh formed by laying two sets of foundation threads, vertical and horizontal.

Whip in the same direction as given for Russian filling but at each intersection the needle is taken through the outside edge of a wheel under the crossed threads of the mesh and out through the opposite edge of the wheel.

When the outside edge of the casket being filled is of an awkward shape, it is often necessary to add an extra ring. When this happens and there are no laid threads ready to attach the ring, it is sometimes possible to sew it direct to the sides of the space, as seen in the centre of the rose in the photograph on page 132.

An interesting filling of individual flowers worked over a cordonnet with buttonhole rings at the centre of each (detail shown below – see also page 132)

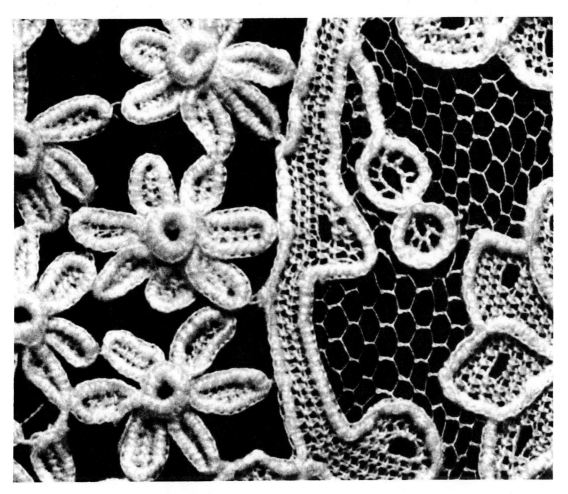

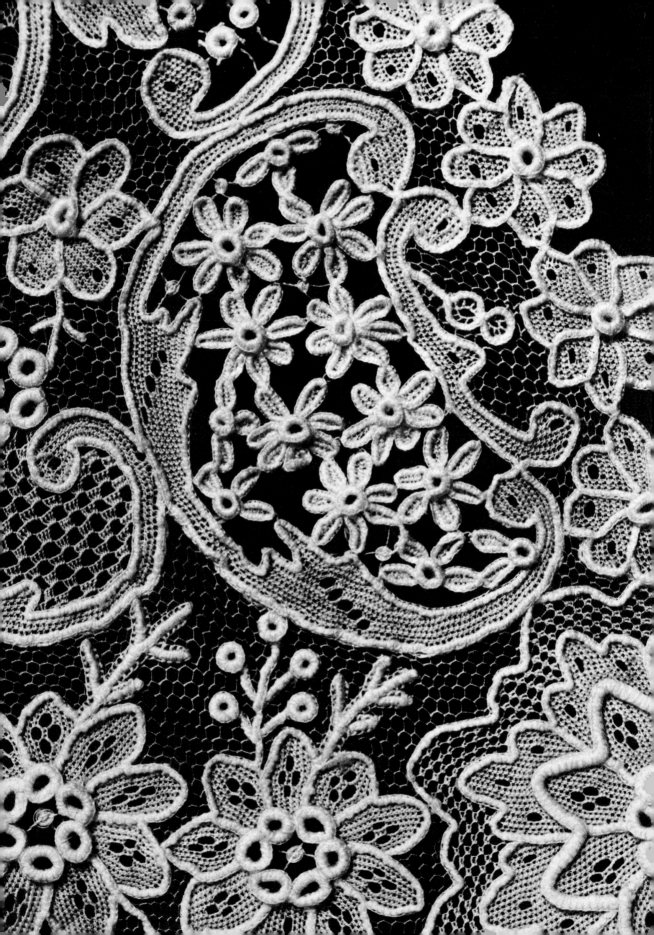

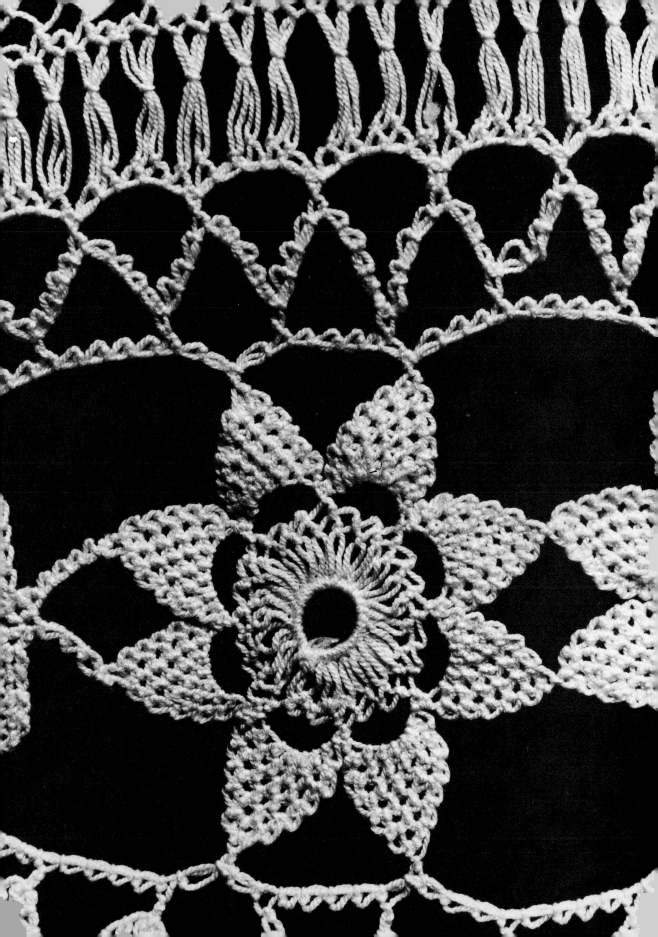

Armenian lace
Smyrna or Rodi stitch

Form the thread into a ring either with the ring stick or by winding round the first finger.

Place the needle behind the threads forming the ring and take the working thread over the needle to the right, then under the needle; do this twice. Draw the needle through, forming a knot on the ring.

Repeat round the ring for the number of loops needed.

The long loops are formed by working a series of Petits Points de Venise leaving enough thread between the stitches to form the loops.

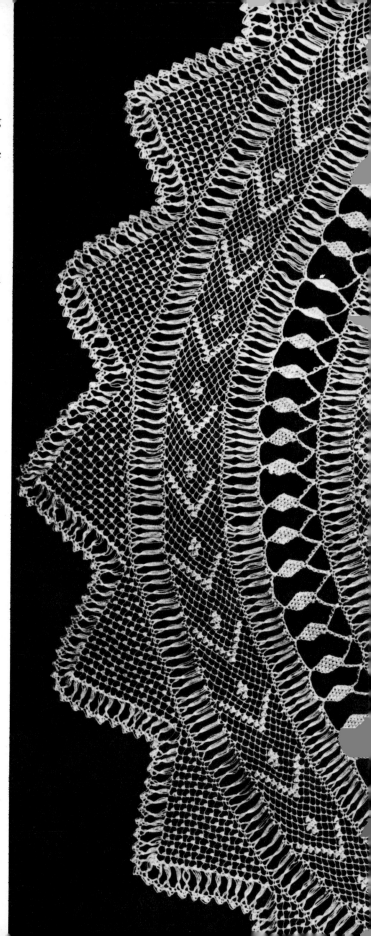

Detail of centre flower (page 133)

Part of an Armenian lace mat. This lace originated in the East and the stitch is called by several different names. The Franciscan nuns in Palestine refer to it as Nazareth stitch, while in Arabic countries it is called Smyrna stitch. In Italy, Malta and other Mediterranean countries it is known as Rodi stitch

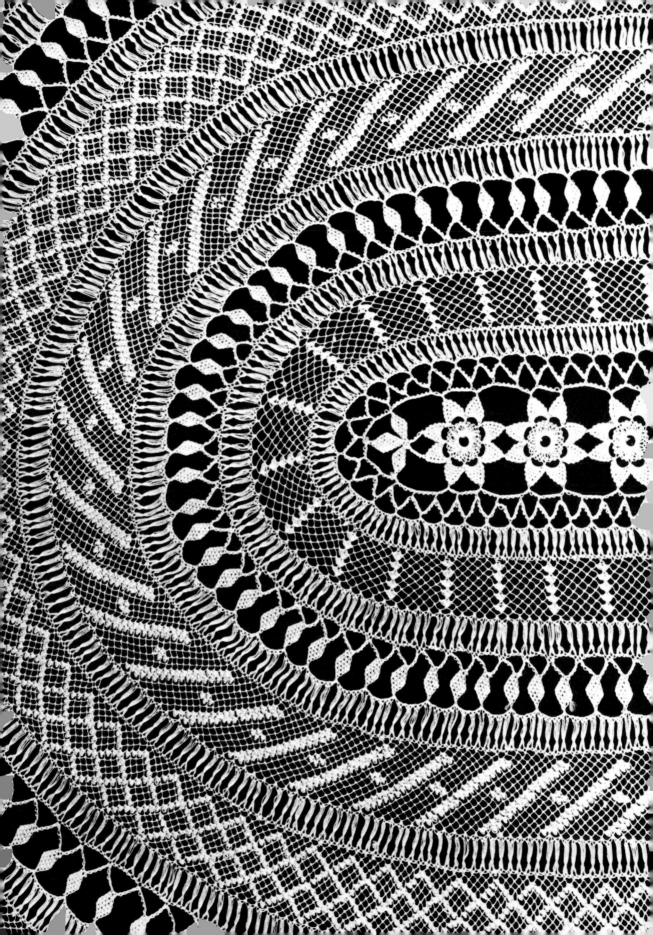

SUPPLIERS

United Kingdom

T Brown Woodside Greenlands Lane Prestwood Great Missenden HP16 0QU	Ring sticks for forming the couronnes
Joanne Graham Cuyahoga Studio 17a Hastings Road Bexhill-on-Sea East Sussex	Machine-made filet net (fine) cut to required size from 150 mm (6 in.) square
Theodore Fabergé 30 Downs Road Hastings East Sussex	Frames for filet lace, meshes from 3 mm to 15 mm ($\frac{1}{8}$ in. to $\frac{5}{8}$ in.), steel and ivory needles
Mace and Nairn 89 Crane Street Salisbury Wiltshire	All lace threads, beeswax, lace scissors, linen lawn, pins
Mrs Sells Lane Cover 49 Pedley Lane Clifton, Shefford Bedfordshire	Acetate film, all lace threads, ball point needles, beeswax, finger shields, glazed cotton, lace scissors, linen lawn, muslin, net, pins, silver thimbles and tambour hooks
Mr Schultz 28 Fairfields Great Kingshill Buckinghamshire HP15 6EP	Bolster pillows for needlepoint lace

USA

Arachne Web works 1227 S W Morrison Portland Oregon 97205	General supplies
Berga-Ullman, Inc P O Box 918 North Adams Massachusetts 01247	Materials and equipment
Frederick J Fawcett 129 South Street Boston Massachusetts 02130	Large selection of linen yarns and threads
Osma G Tod Studio 319 Mendoza Avenue Coral Gables Florida 33134	Books, instructions, materials and equipment
Robin and Russ Handweavers 533 N Adams Street McMinnville Oregon 97128	Books, materials and equipment
Some Place 2990 Adeline Street Berkeley California 94703	Books, instructions, materials and equipment
The Unique and Art Lace Cleaners 5926 Delmar Boulevard St Louis Missouri 63112	Professional lace cleaning and restoration
Serendipity Shop 1547 Ellin wood Des Plaines Illinois 60014	General supplies

BIBLIOGRAPHY

Caulfield, S. F. A., and Saward, B. C., *Dictionary of Needlework*, L. Upcott Gill, 1880; facsimile reprint, Hamlyn, 1972

de Dillmont, Therèse, *Encyclopaedia of Needlework*, DMC, first published 1897

Leigh Lowes, Emily, *Chats on Old Lace*, T. Fisher Unwin, 1908

Neville Jackson, E., *The History of Handmade Lace*, L. Upcott Gill, 1900

Palliser, F. B., *A History of Lace*, reprinted from the 1902 edition by EP Publishing Ltd, 1976

Powys, Marion, *Lace and Lace Making*, Charles T. Branford Co, 1953

Wardle, Patricia, *Victorian Lace* in 'The Victorian Collector Series', Hubert Jenkins, 1968

Woodward, A., *Lace*, The Journal of the Lace Guild, Berkhampstead, Herts.

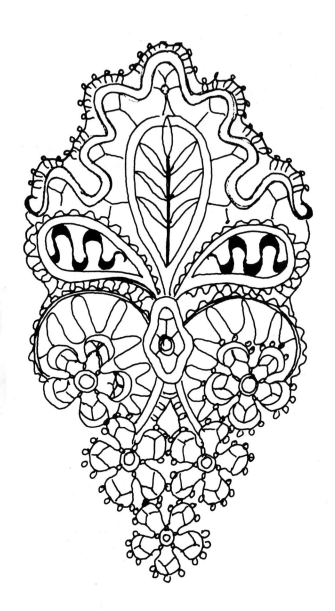

INDEX

Alençon beads 102
 mesh 83
Ardenza Point ground 84
Armenian 134
Atterbury, Francis 33

Bars, Alençon 102
 Ardenza 87
 branching 101, 102
 bullion 101
 de Grecque 96
Base fabric 67
Bowys 41
Brides ornées 15
Burano, Island of 25
Buttonhole rings 131

Cardinal's lace 21
Carrickmacross 45
 designs for 120
 design for angel 114
Catherine de Medici 29
Caveliers Merli 21
Coggeshall lace 43
Colbert, Jean Baptiste 29
Corded filling 93
Cordonnet 7, 11, 15, 18, 67, 70
Cordonnette 11, 15, 18
Couching 70

Designing 55–64
 practice designs 68
Duke of Devonshire 32

Engrêlure 15, 17

Filet 106
Fill de Trace 69
Fisherman's knot 110

General hints 73
Grey Porter, Mrs 45

Hammock, working details 111
Hollie lace 42
 stitch 103

Irish Appliqué 111
 Guipure 114

Jours 15

Lattice filling 89
Legs 15
Limerick lace 115
 fancy fillings 121, 122
 heavy fillings 121
 light fillings 122
 Point Croisé 125
 Point Serré Closed Diamond 124
 Point Serré Double Diamond 124
Point Tiellage 125

Mackette, Elizabeth 41
Mantilla, Spanish 27
Meshwork 15, 83
Modes 15

Needles 67
Netting 109

O'Brien, Mrs Vere 48
Oval space filling 95

Passement au Fuseaux 11
Pea filling 95.
 stitch variation 95
Picots, loop 97
 Venetian 97
Points
 Ardenza 84
 Argentan or Bride d'Epingle 83
 Belle Point de Venise 76
 de Bruxelles 89
 d'Esprit 126
 de Gaze 38
 de Grecque 96
 Petit Point de Venise 73
 Spanish or Point d'Espagne 79
 Sorrento 80
Pope lace 21
Poupée 33

Punto in Aria 11
 Tagliato 11
 Tirato 7
Purls 101

Ragusa 33
Raised work 11, 15, 17
Reid, Miss 45
Réseau for Argentan Point 83
Rodi stitch 134
Russian filling 130

Sans Sols 82
Seaming lace 41
Smuggling 29, 33
Smyrna stitch 134
Spanish Columns 79
Sprang 7

Tambour, *see* Coggeshall lace
Tebbs sisters 42
Tenerife lace wheel 80
Thorns 15
Threads 67
Ties 15
Toile 15, 18
Toilé 18

Uttmann, Barbara 49

Venetian doodle 76
 motifs 77

Walker, Charles 45
Wheel Garland 130
 ground 103
Woven bars 11, 125, 126
 pyramids 93, 126

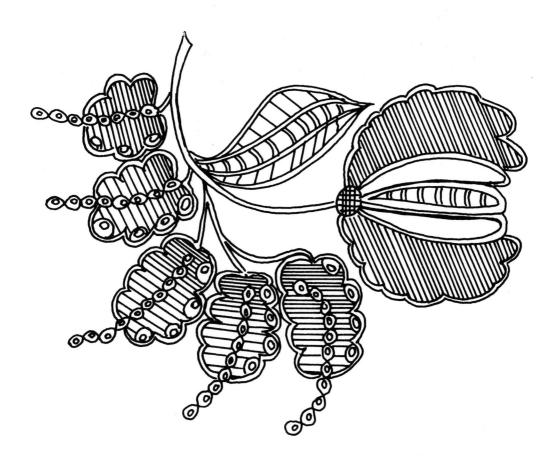